THE GOLDEN RATIO

COLORING BOOK

AND OTHER MATHEMATICAL PATTERNS
INSPIRED BY NATURE AND ART

STEVE RICHARDS

LARK

New York

D1275583

LARK
New York

An Imprint of Sterling Publishing Co., Inc.
122 Fifth Avenue
New York, NY 10011

First published in the United Kingdom in 2016 by Michael O'Mara Books Ltd., as
The Golden Ratio Colouring Book

ISBN 978-1-4547-1022-6

Distributed in Canada by Sterling Publishing
c/o Canadian Manda Group, 664 Annette Street
Toronto, Ontario, Canada M6S 2C8

For information about custom editions, special sales, and premium
and corporate purchases, please contact Sterling Special Sales at
800-805-5489 or specialsales@sterlingpublishing.com.

Manufactured in Malaysia

6 8 10 9 7

sterlingpublishing.com/larkcrafts

Designed by Claire Cater
Illustrations by Steve Richards

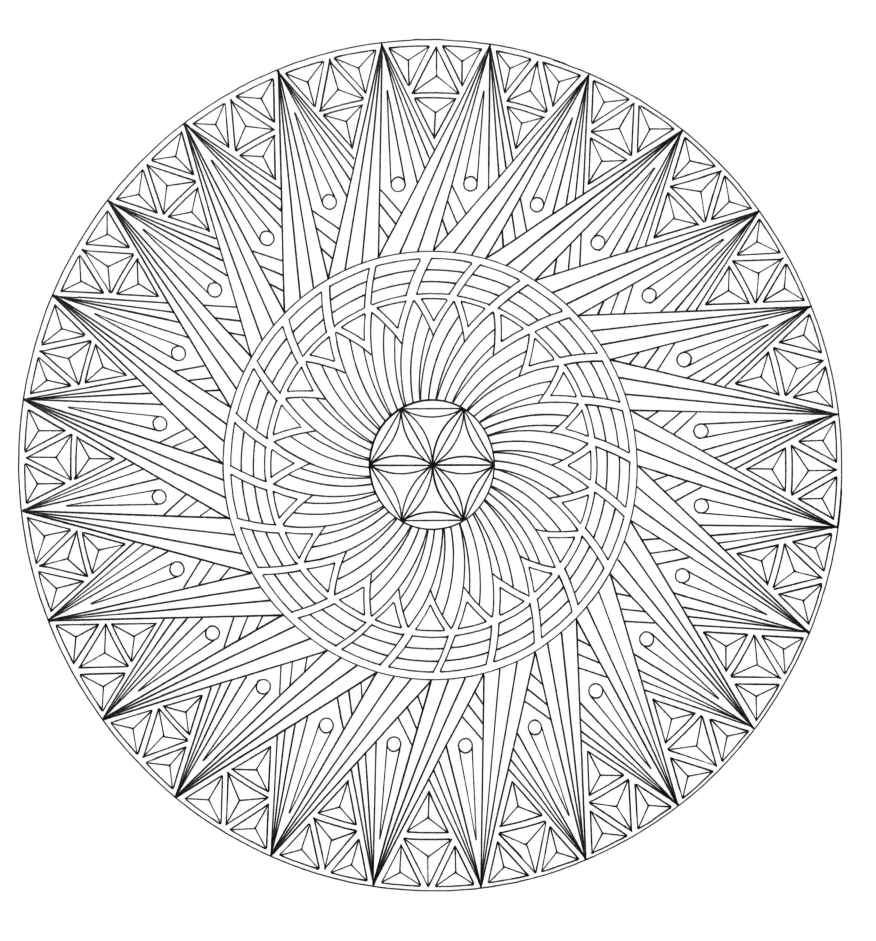

WHAT IS THE GOLDEN RATIO?

Phi is the irrational number (approximately 1.618) which we represent using the symbol Φ. It can be derived from a geometric quality—if we divide a line length x into two sections of lengths y and z, so that the ratio x:y is the same as the ratio y:z, then each of these ratios is equal to phi. Phi is also known as the golden ratio, the golden mean or the divine proportion.

Alternatively, if we construct a rectangle using the method below, the ratio between the width and height of the rectangle is phi. This "golden rectangle" has historically been seen as one of special beauty—many architects and painters have incorporated it in their work. It can, for instance, be observed in buildings as varied as the Parthenon, Notre Dame cathedral, and the Taj Mahal. It is also the basis of the image opposite, which radiates out from four central interlocking golden rectangles.

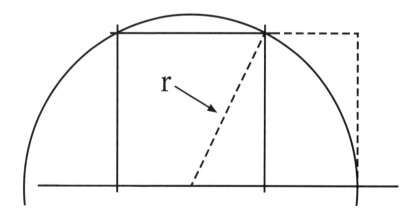

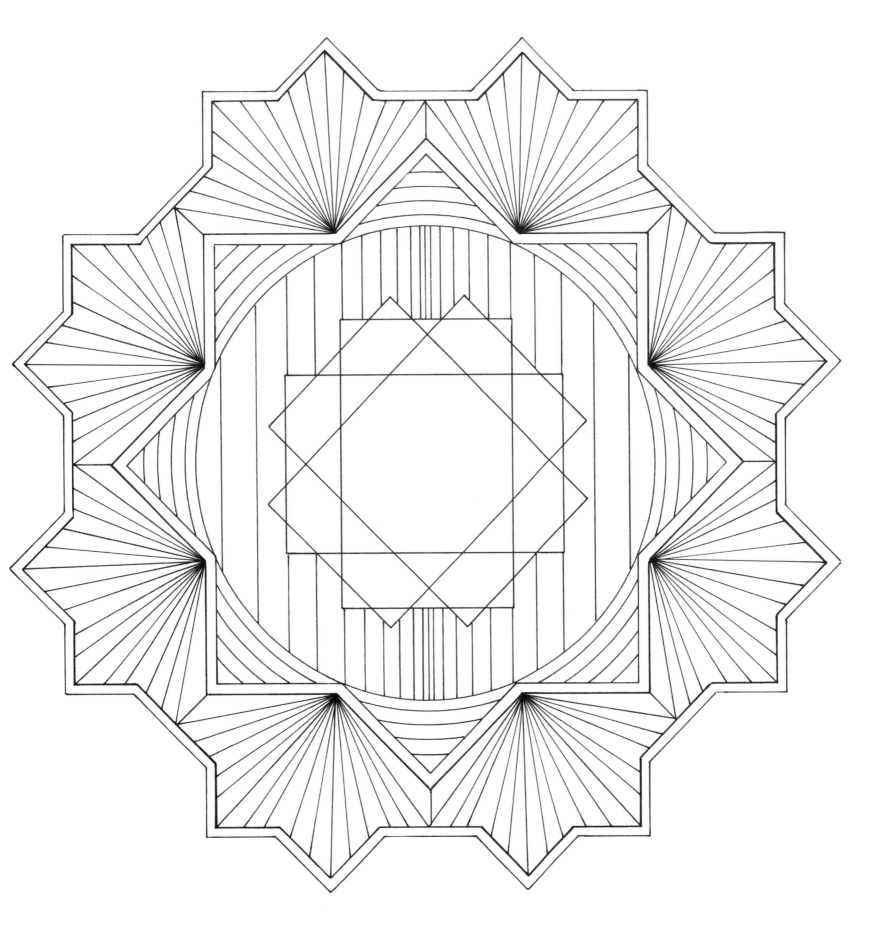

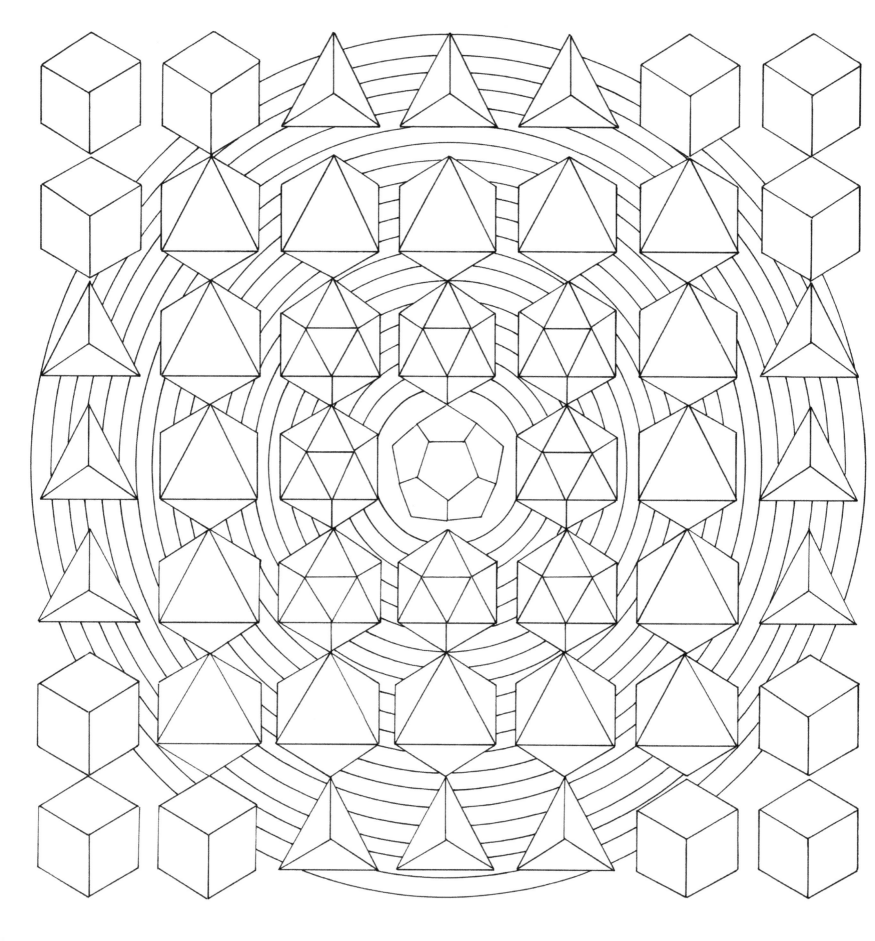

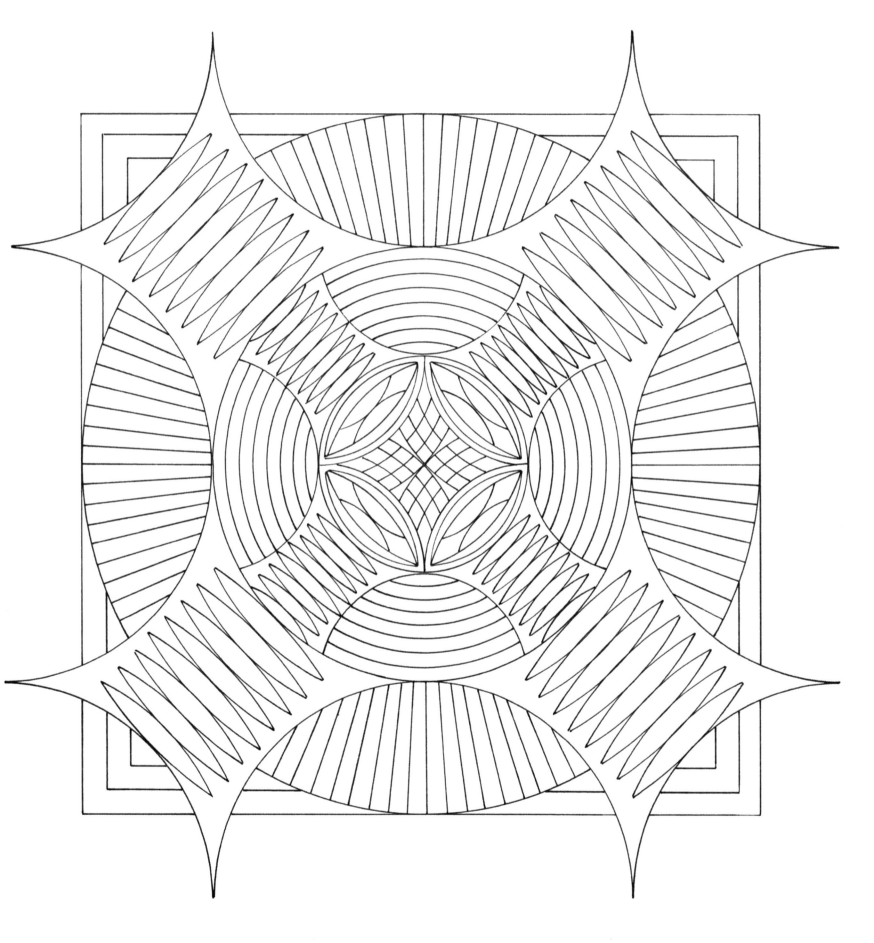

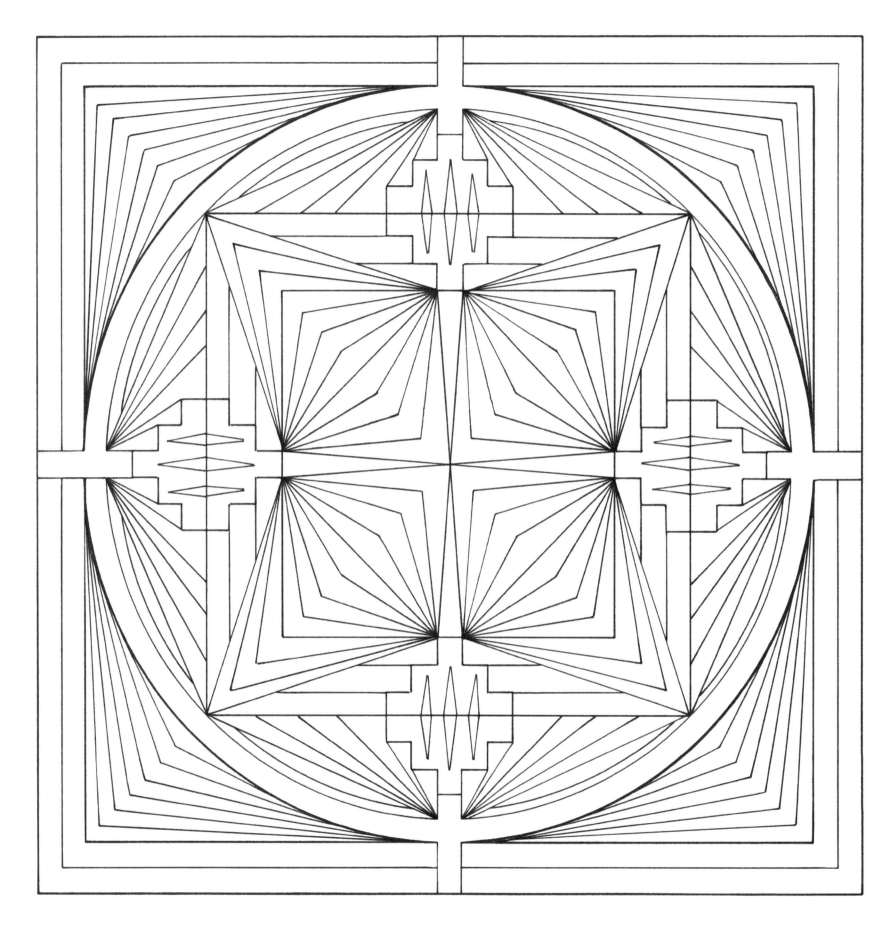

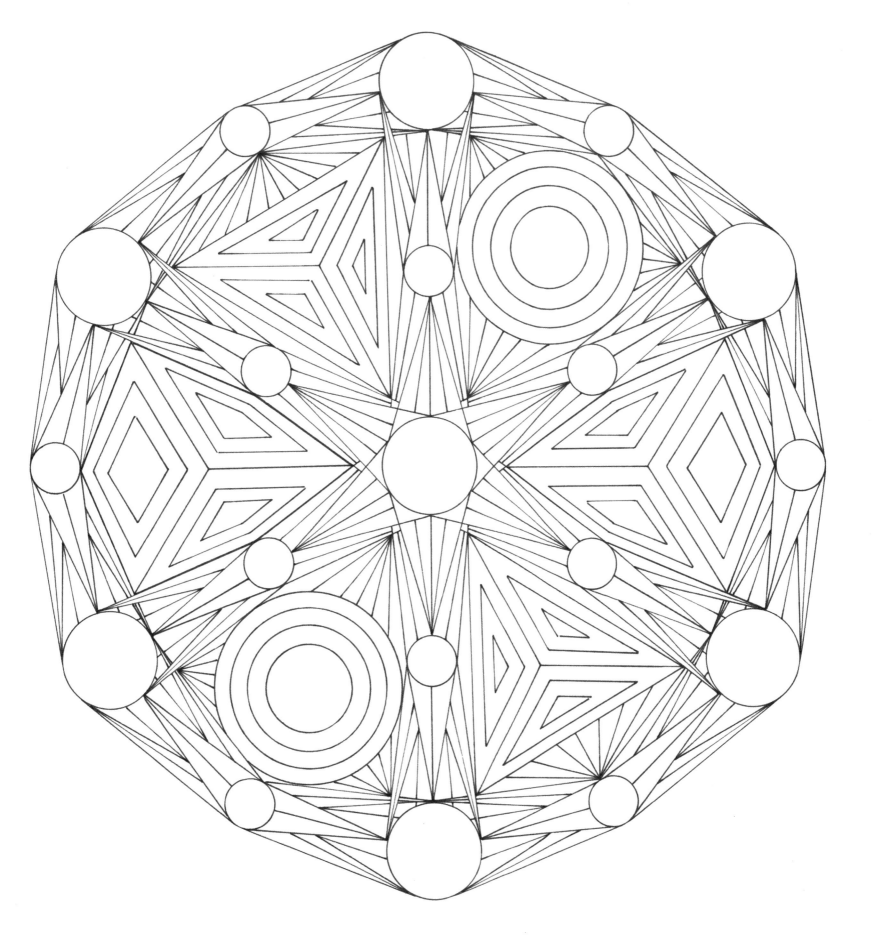

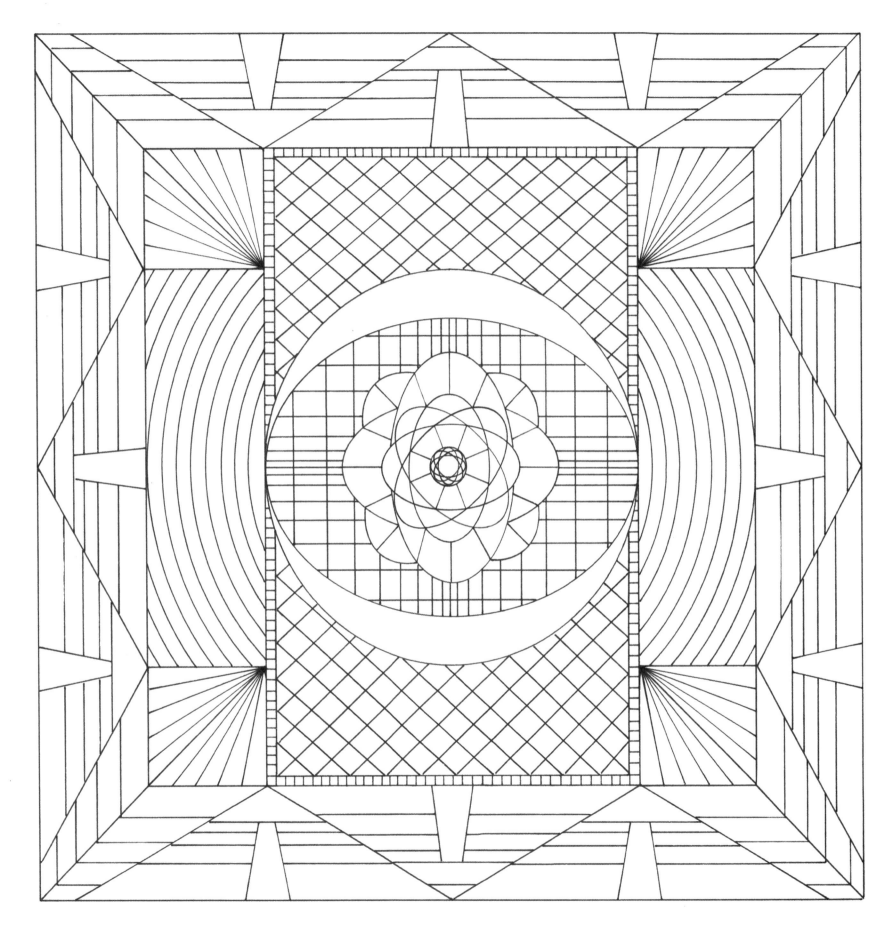

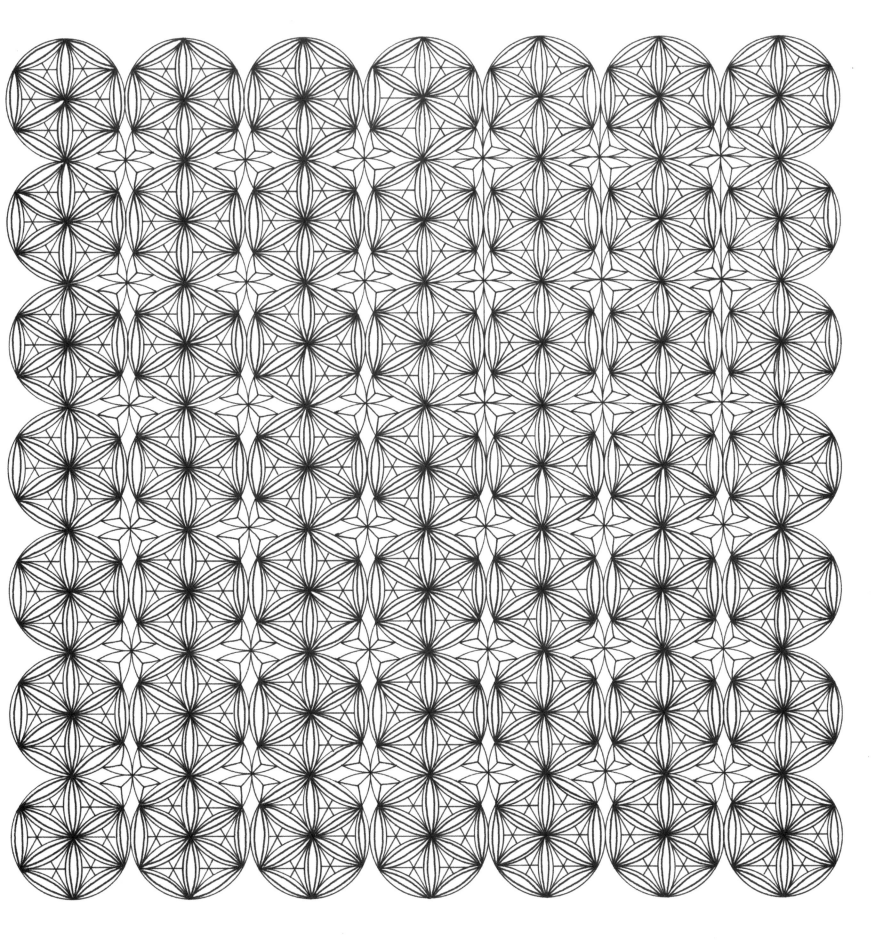

THE FIBONACCI SPIRAL

The Fibonacci series is named after the brilliant medieval Italian mathematician, also known as Leonardo of Pisa, who popularized an idea already known to earlier Indian thinkers. It starts with 0 and 1 (or 1 and 1), then at each stage we add the previous two numbers in the series to find the next one: 1, 1, 2, 3, 5, 8, 13, 21, 34 … The ratio between consecutive numbers in the Fibonacci series approaches phi—the golden ratio—as they become increasingly large.

By connecting the corners of the squares in a Fibonacci tiling, constructed, as below, from consecutive Fibonacci numbers, you can create a Fibonacci spiral (which is very similar to the smoother logarithmic spiral). This pattern is (approximately) replicated in an astonishing variety of natural phenomena, from nautilus shells, pine cones, and sunflower seeds to weather patterns and even solar systems.

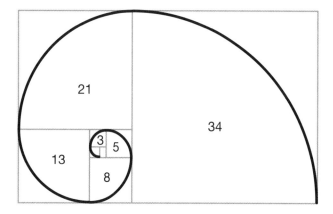

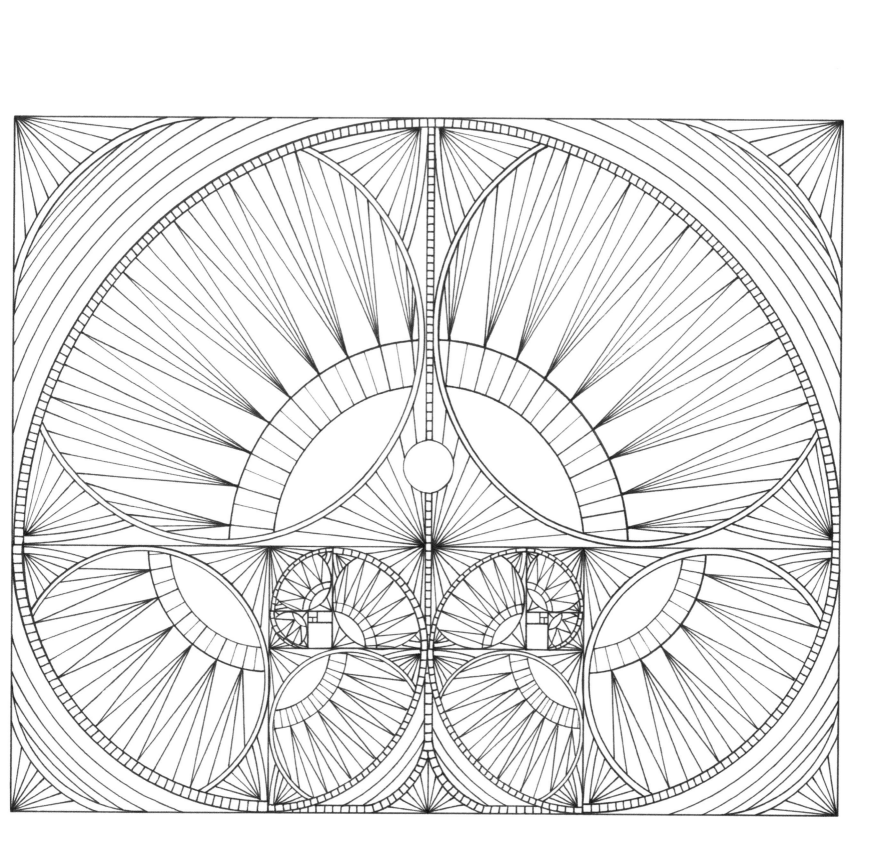

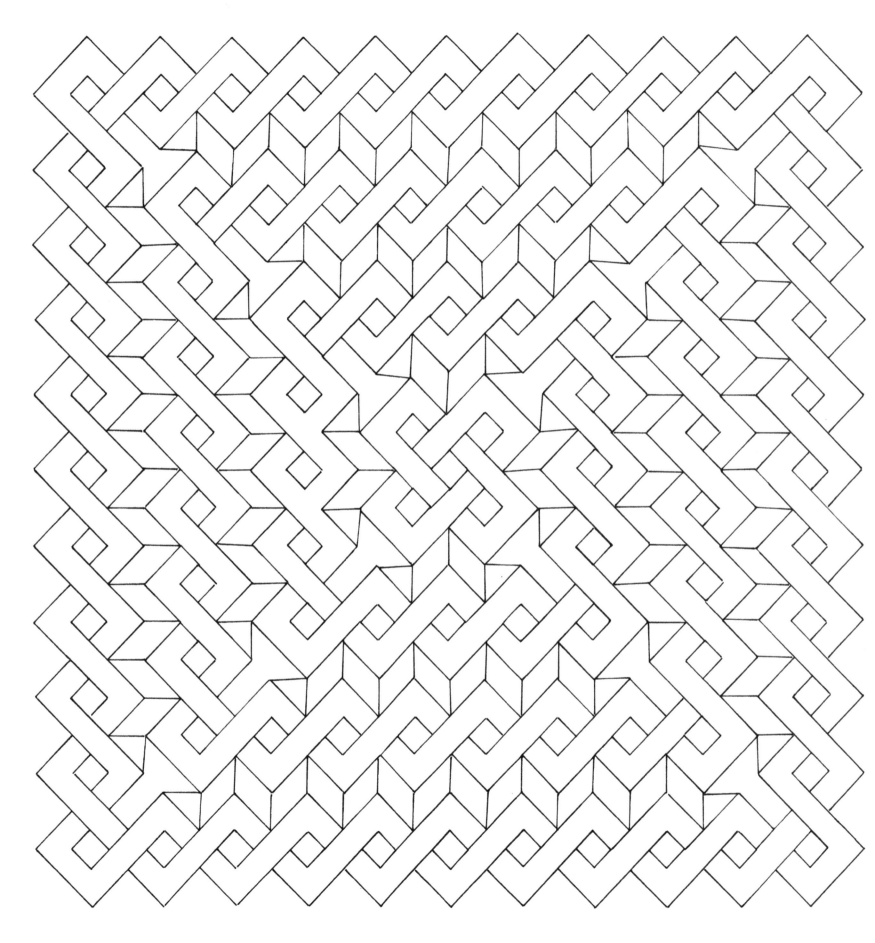

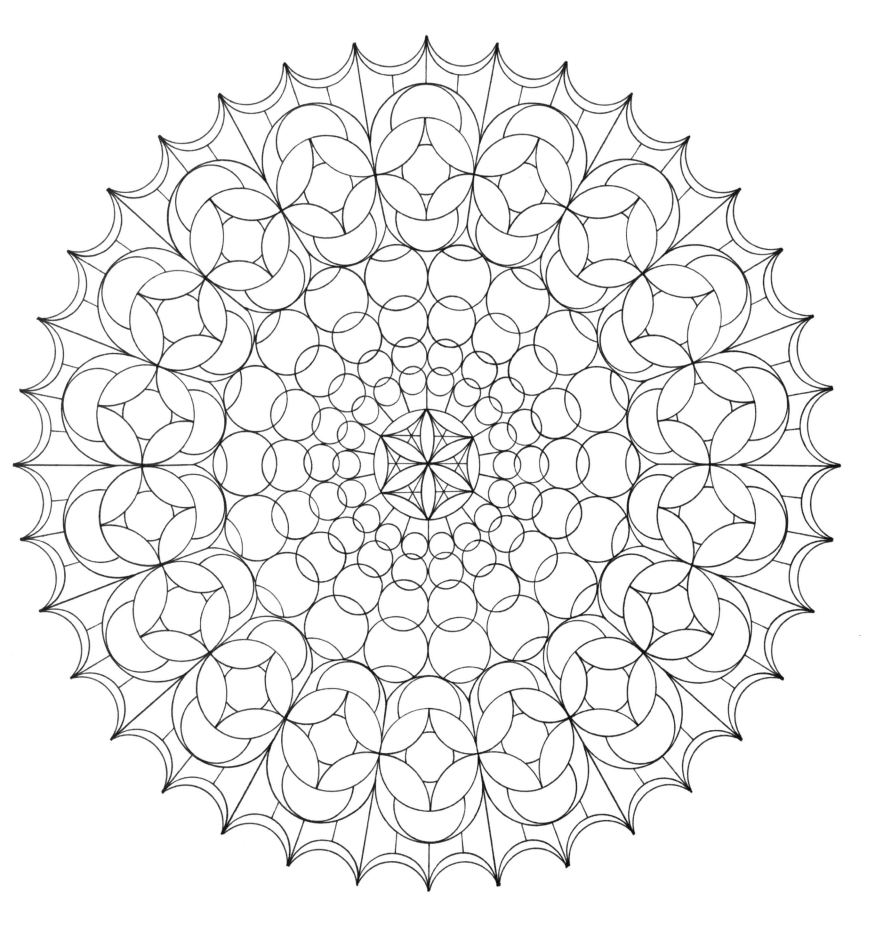

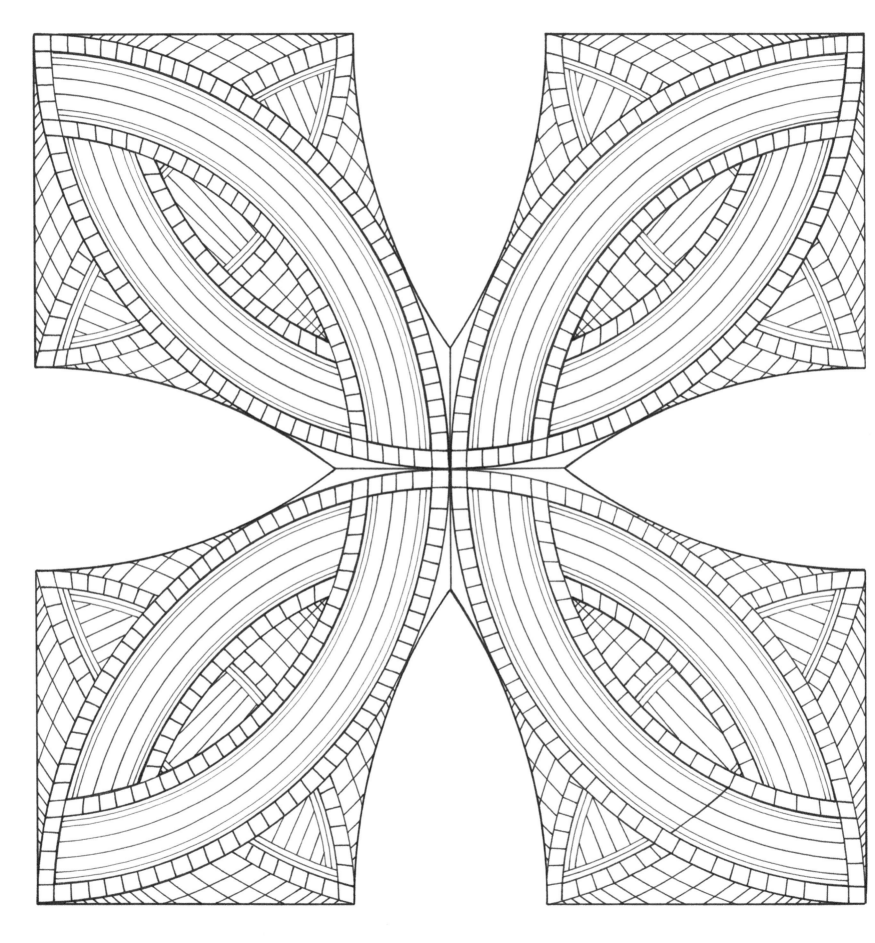

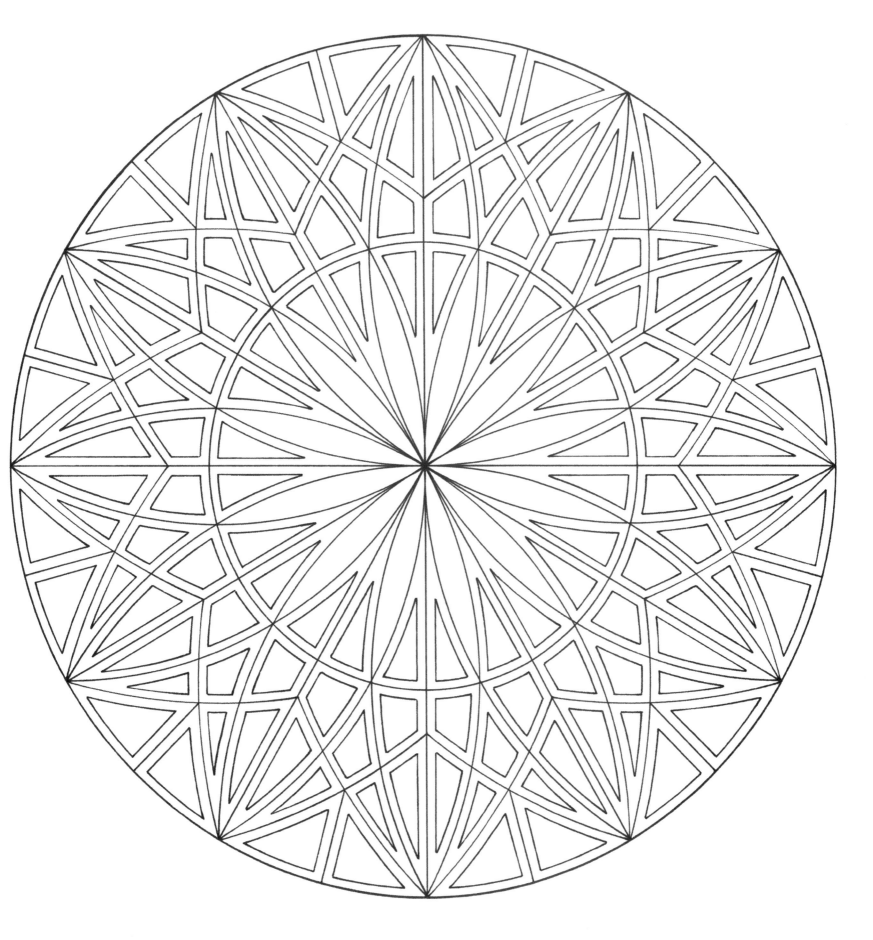

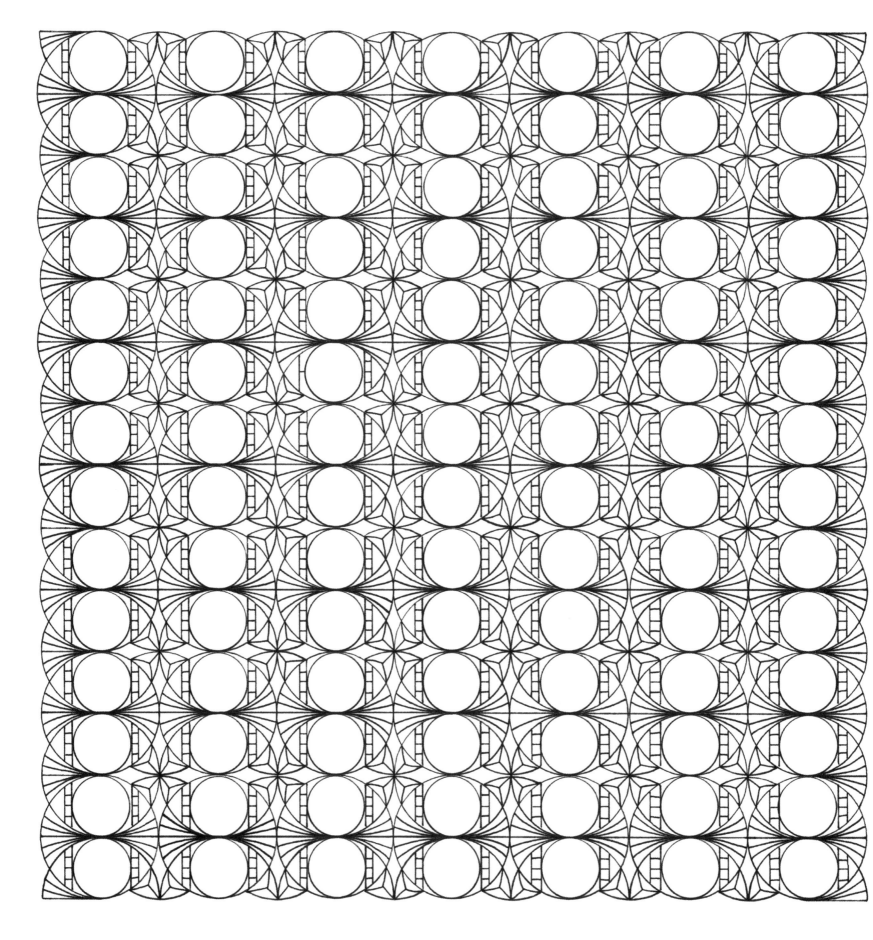

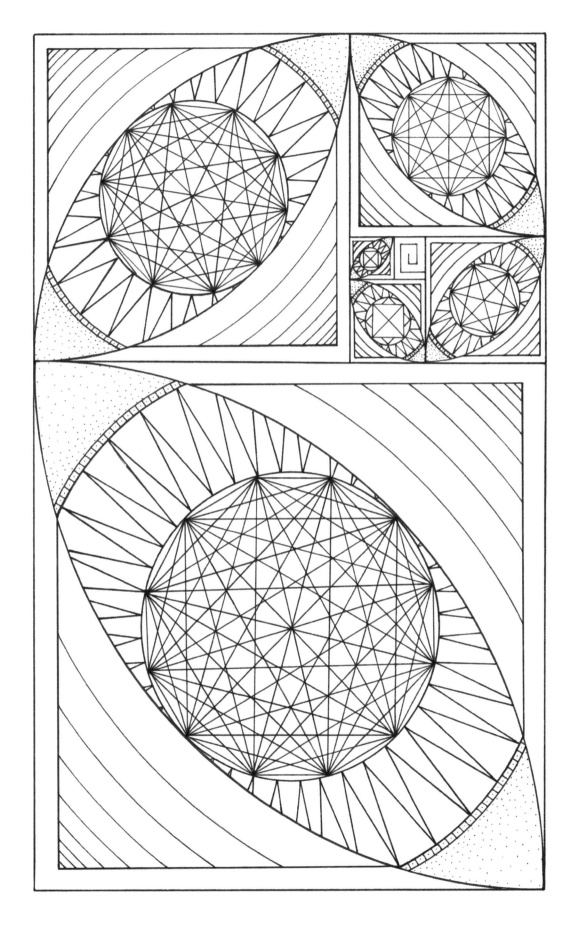

SPIRA MIRABILIS

The mathematician Jacob Bernoulli described the logarithmic spiral, the self-similar curve that is closely related to the Fibonacci sequence, as Spira mirabilis ("the marvellous spiral"). Using the same basic principle, architects and designers have created a wide variety of curved patterns that mimic the patterns found in shells and flowers.

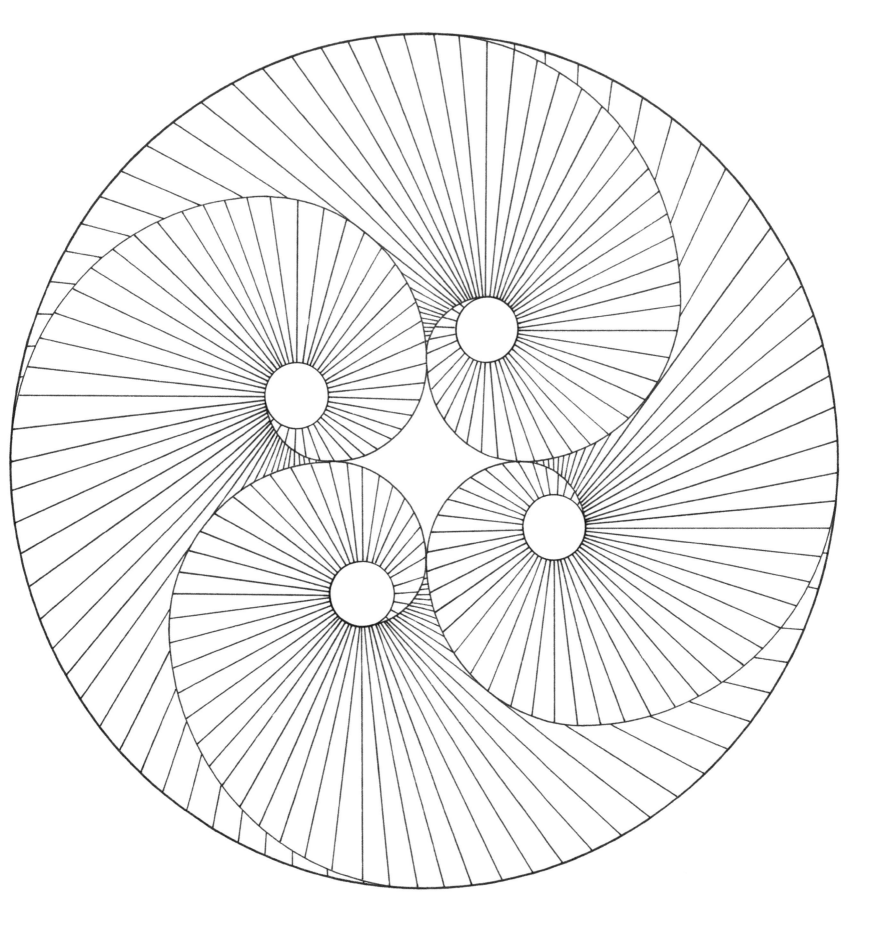

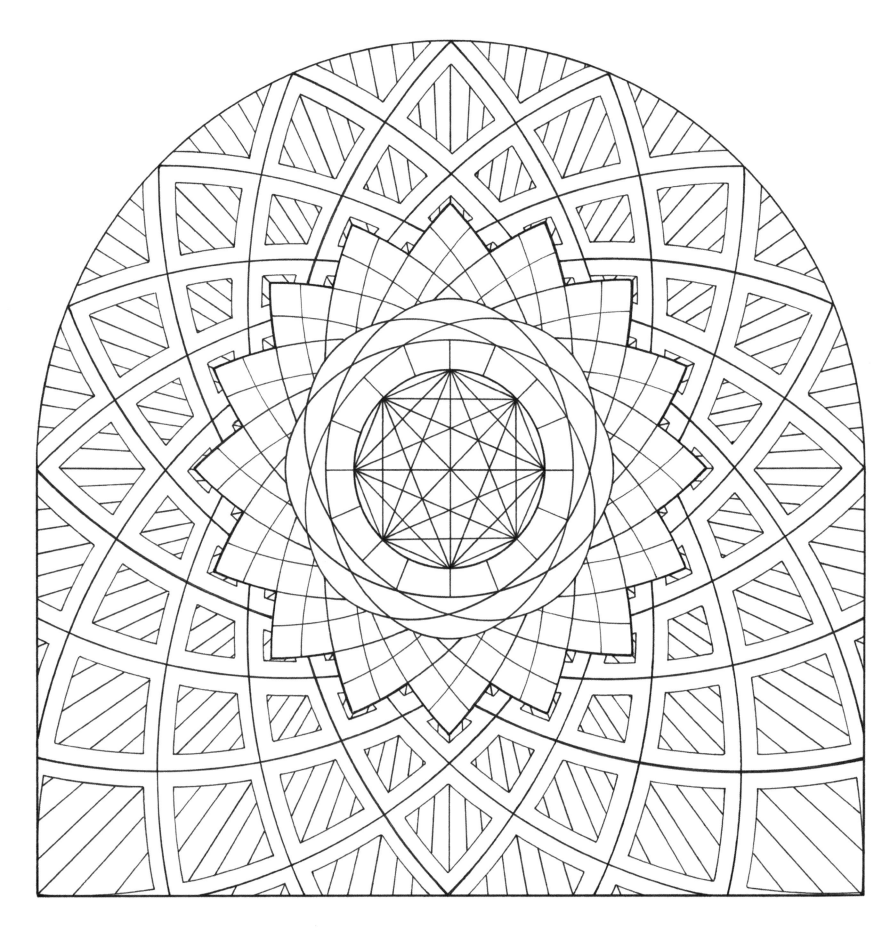

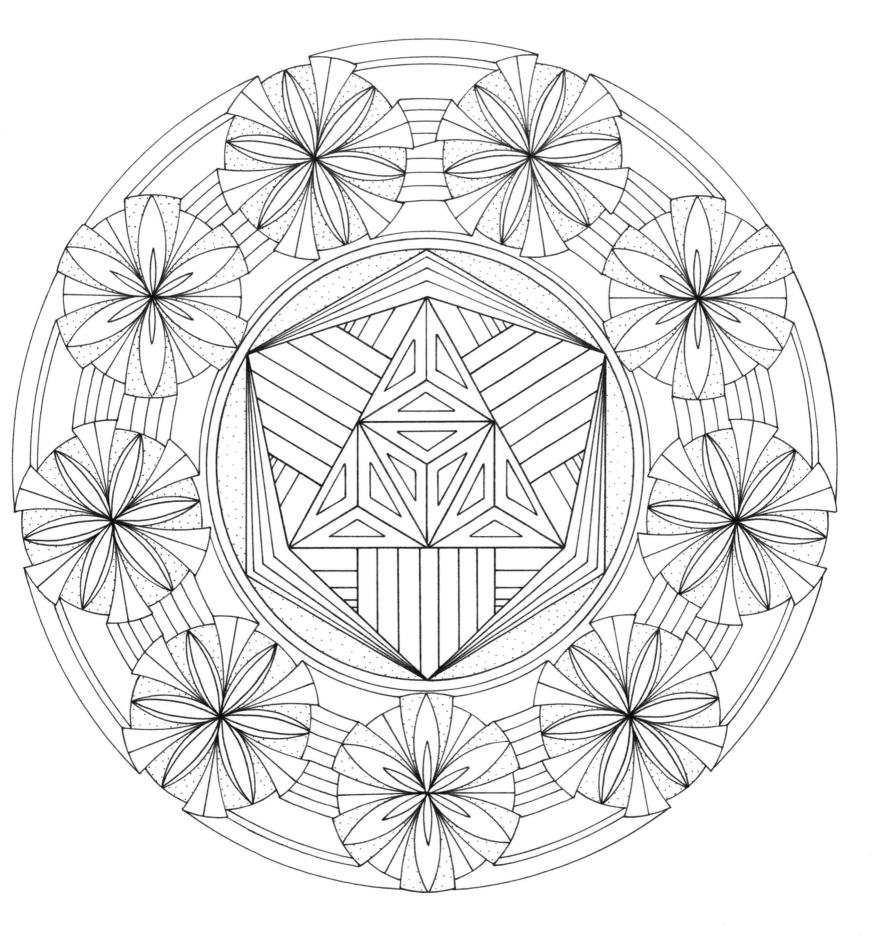

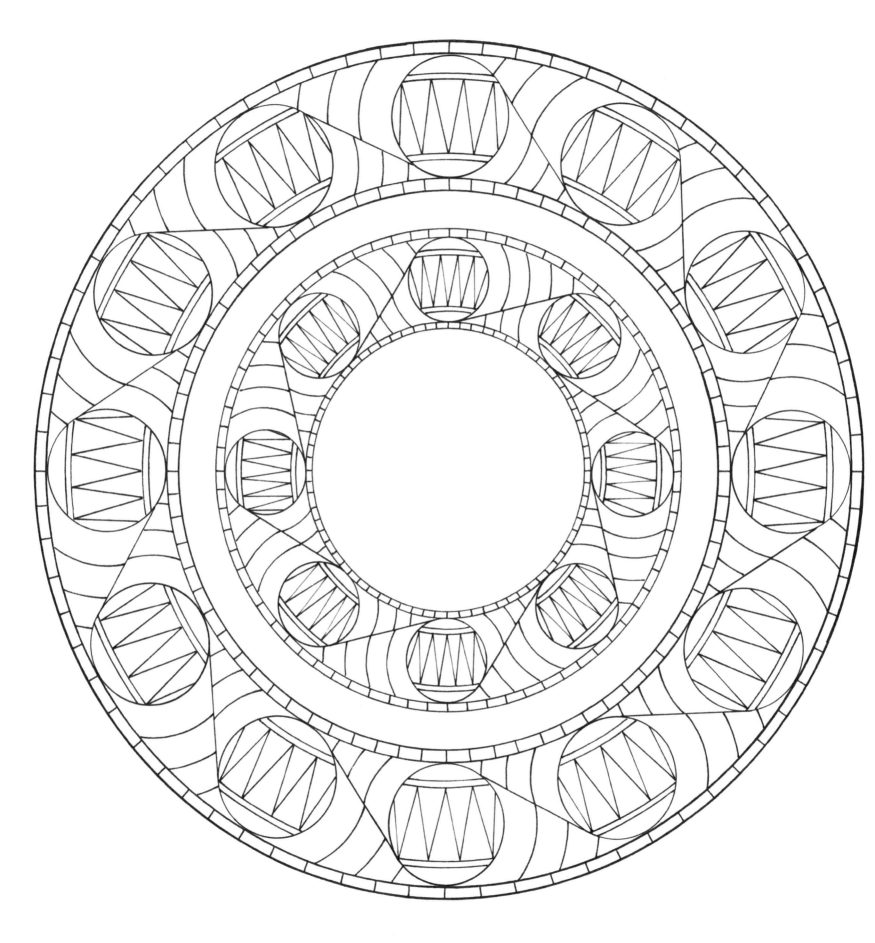

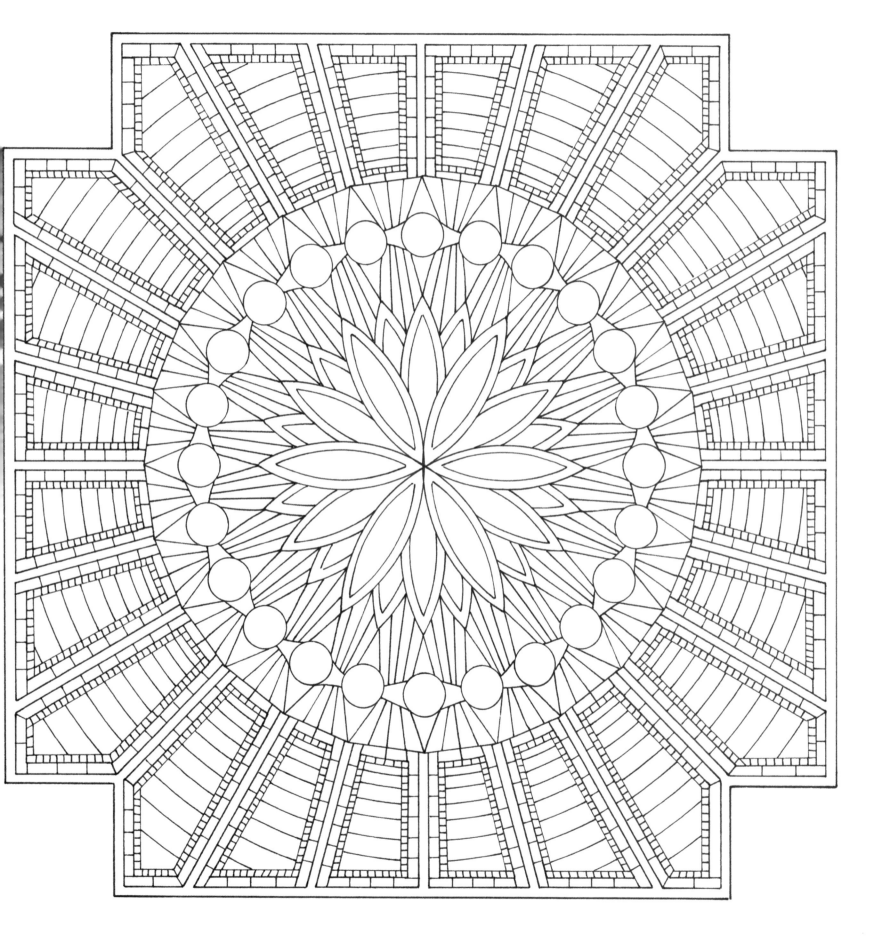

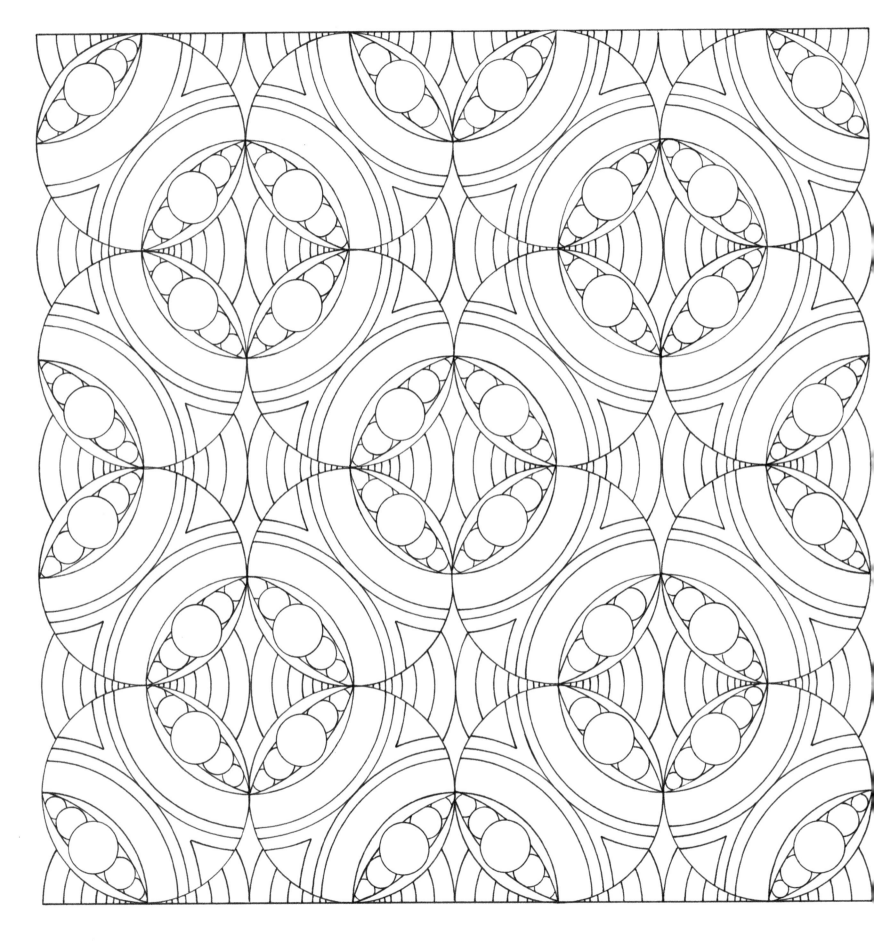

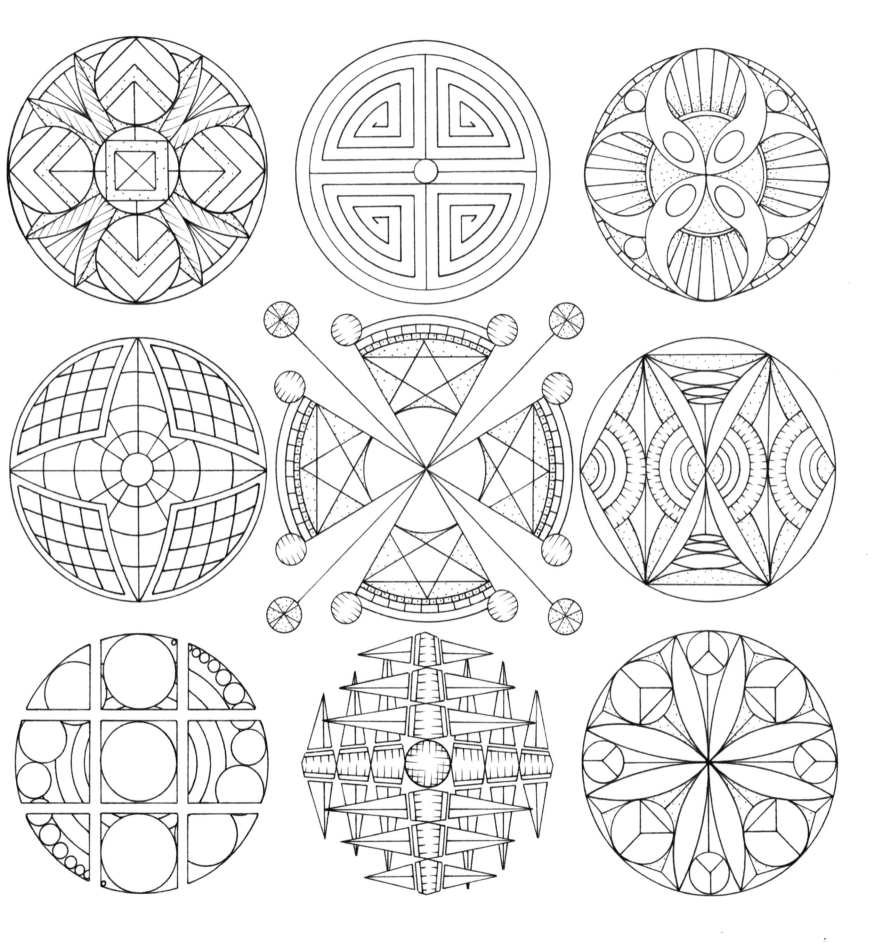

PLATONIC SOLIDS

A Platonic solid is an object with regular polygonal faces,
and with the same number of faces meeting at each corner.
For instance, a cube has six faces and three squares
meeting at each of its six corners. There are only five such
solids, each of which features in the five interior circles
opposite: (clockwise from top left) tetrahedron, cube,
icosahedron, octahedron and (center) dodecahedron.

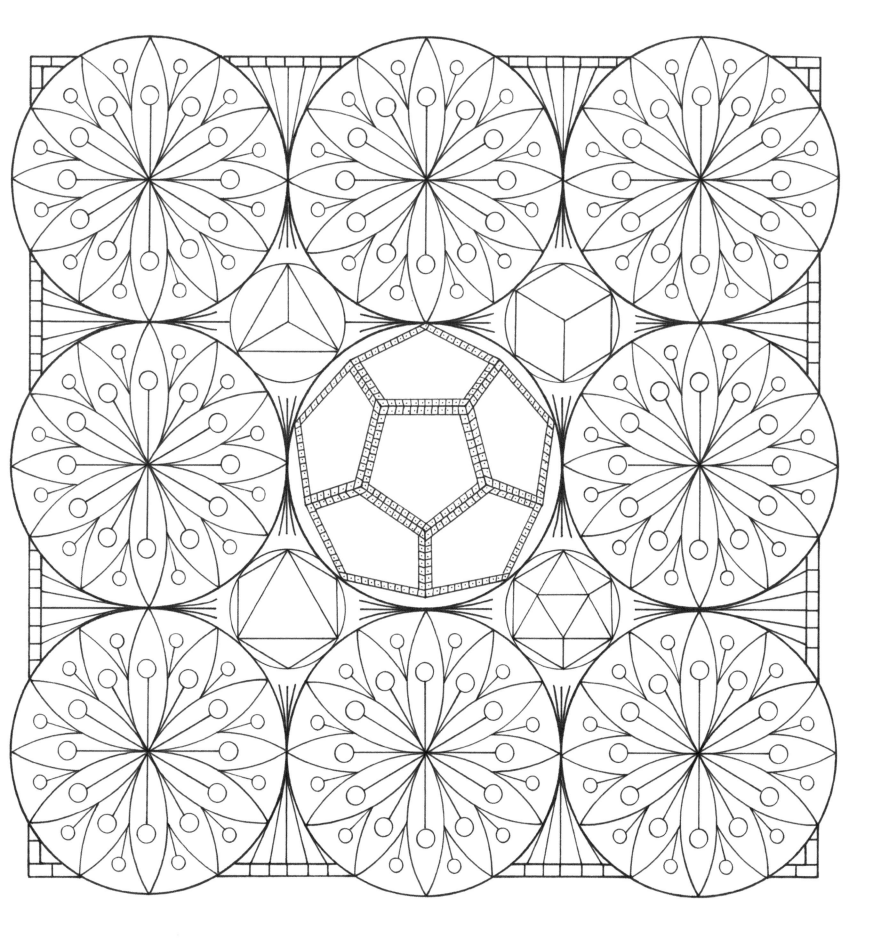

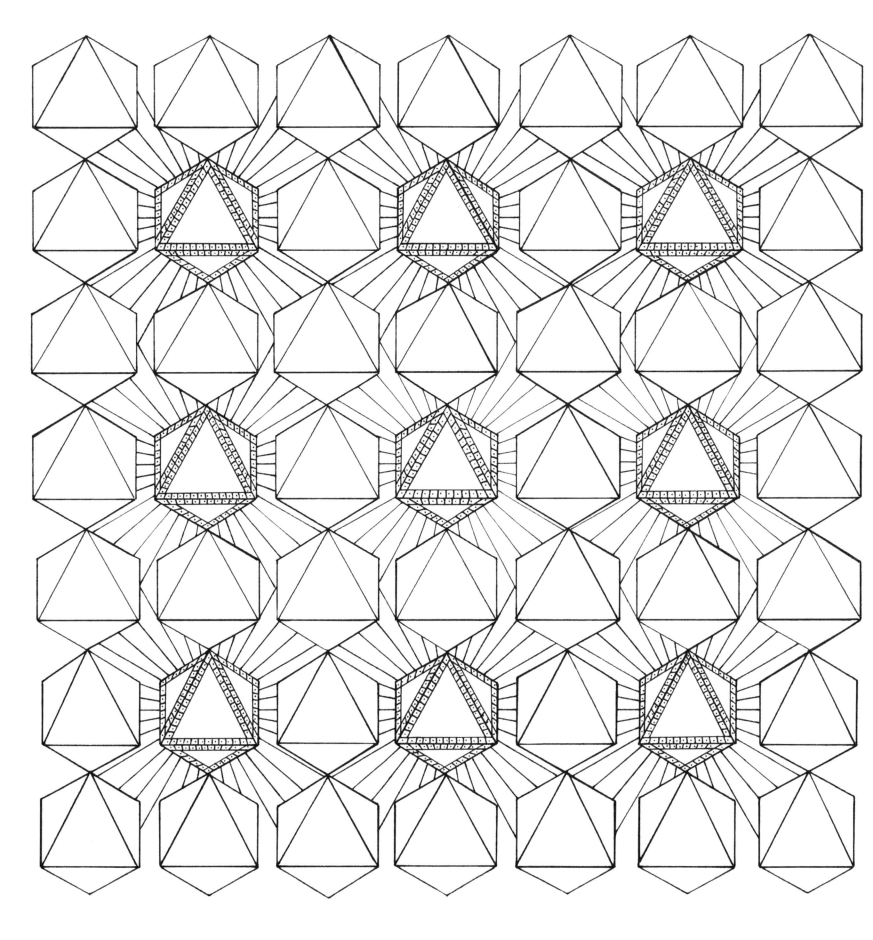

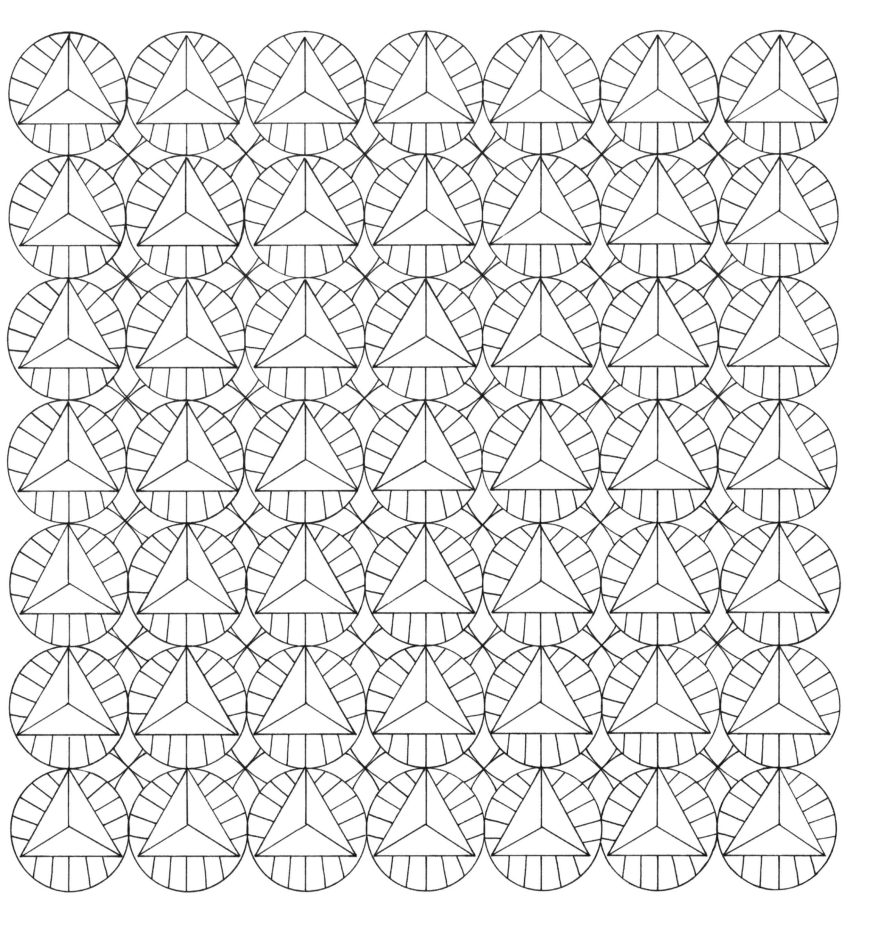

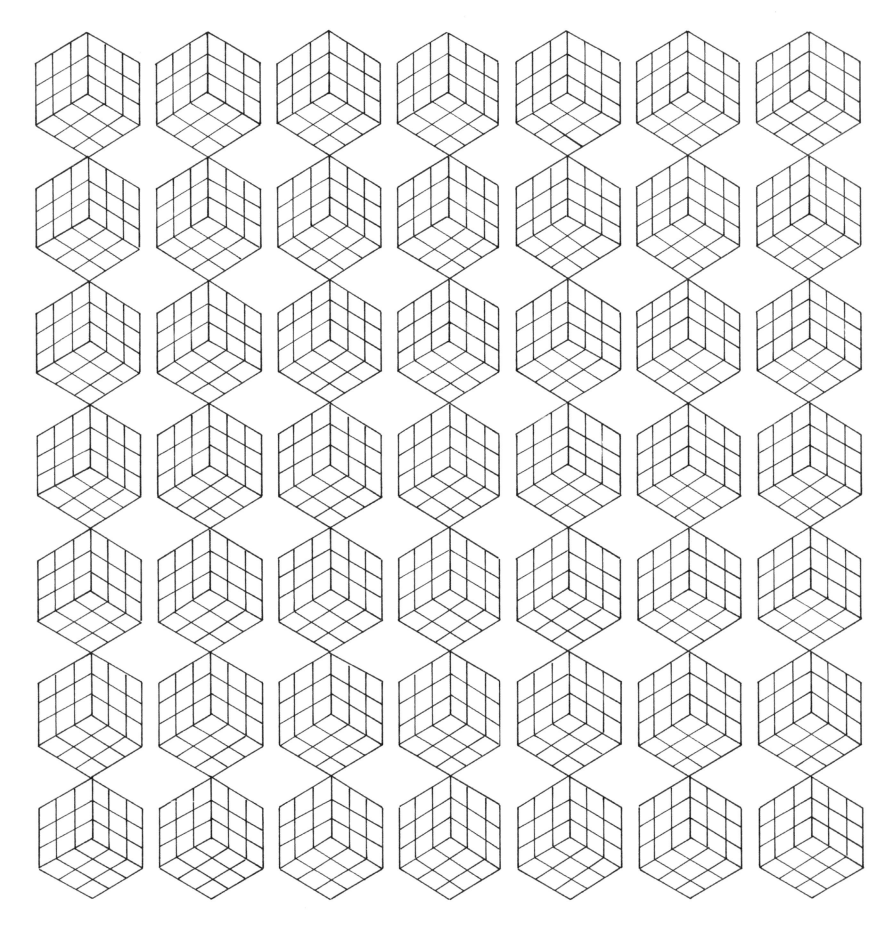

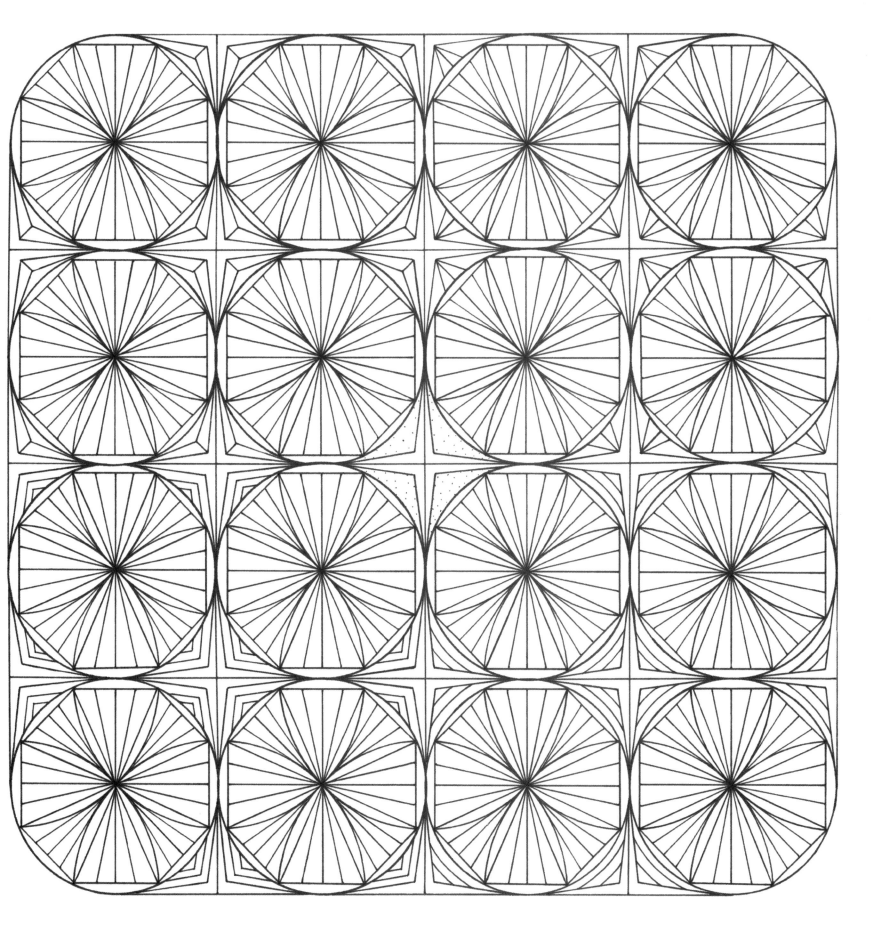

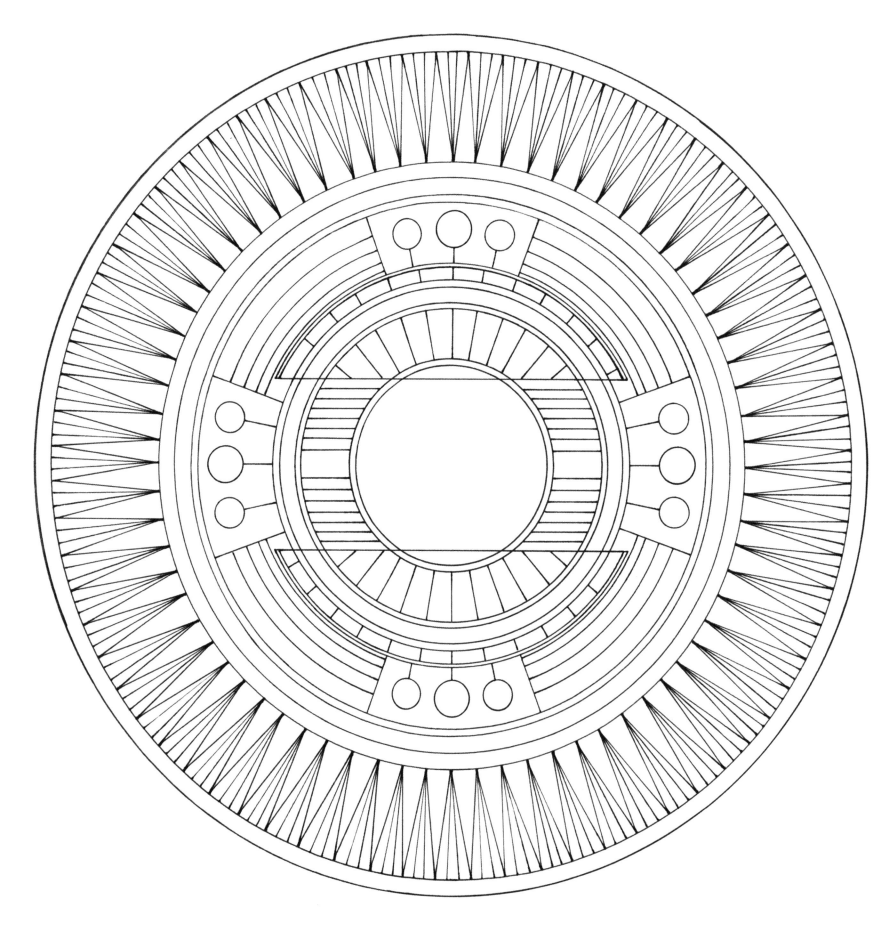

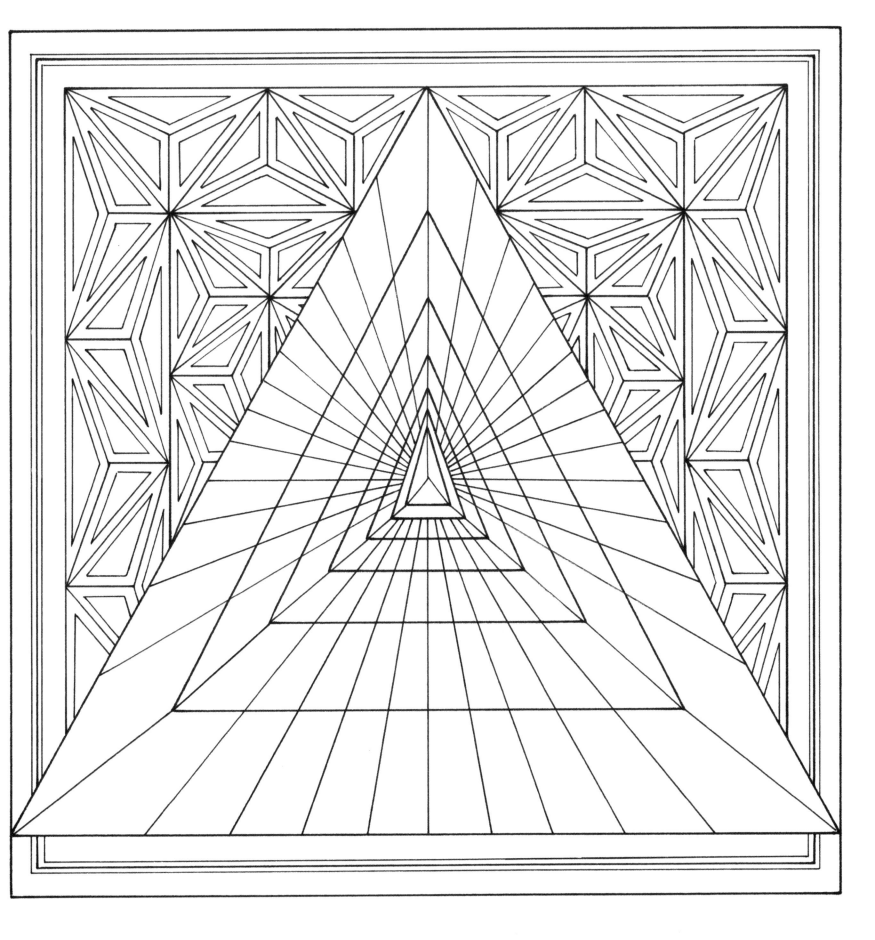

THE ICOSAHEDRON

There are numerous fascinating connections between the Platonic solids and the golden ratio. For instance, three intersecting golden rectangles can be used to map out the points of an icosahedron, which has twenty triangular faces and twelve corners, at each of which five triangular faces meet (see below). The corners of the same three rectangles would also touch the exact centers of each of the twelve faces of a dodecahedron.

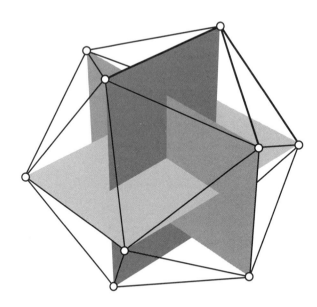

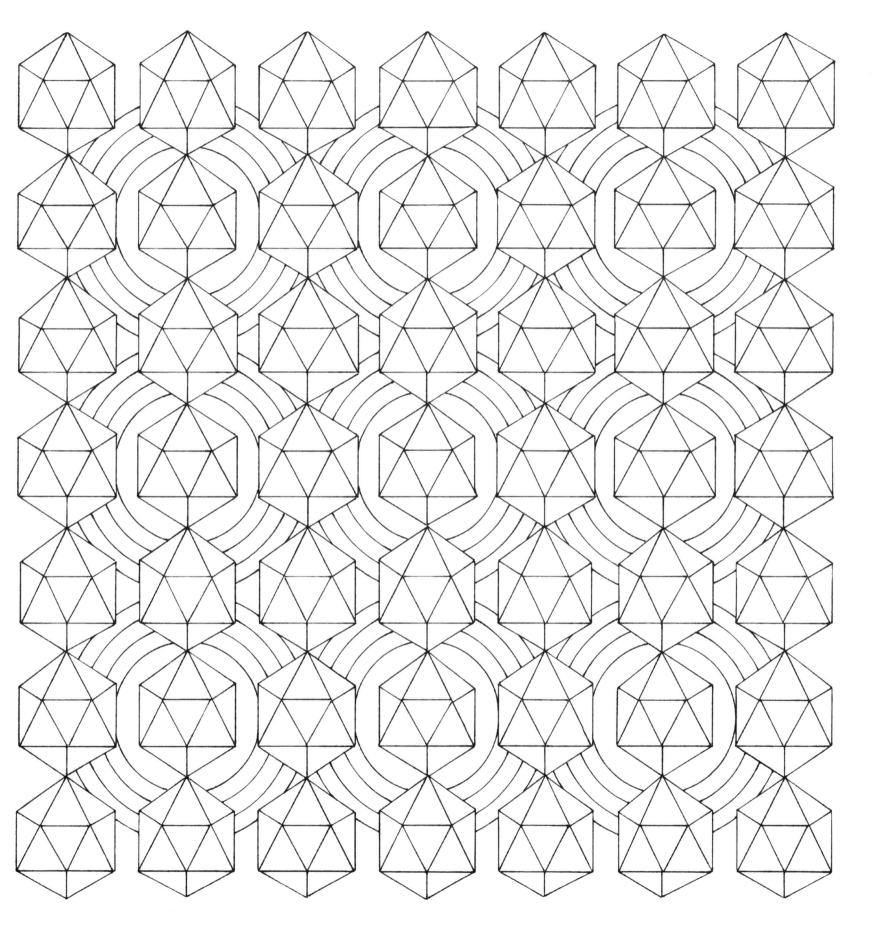

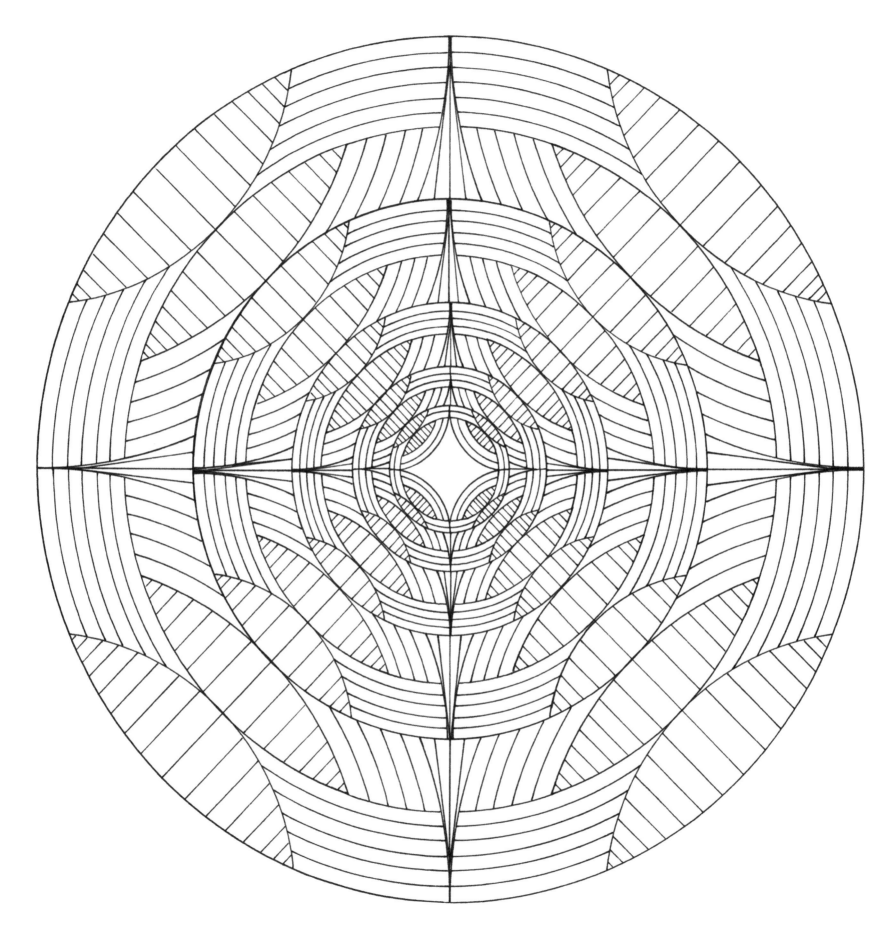

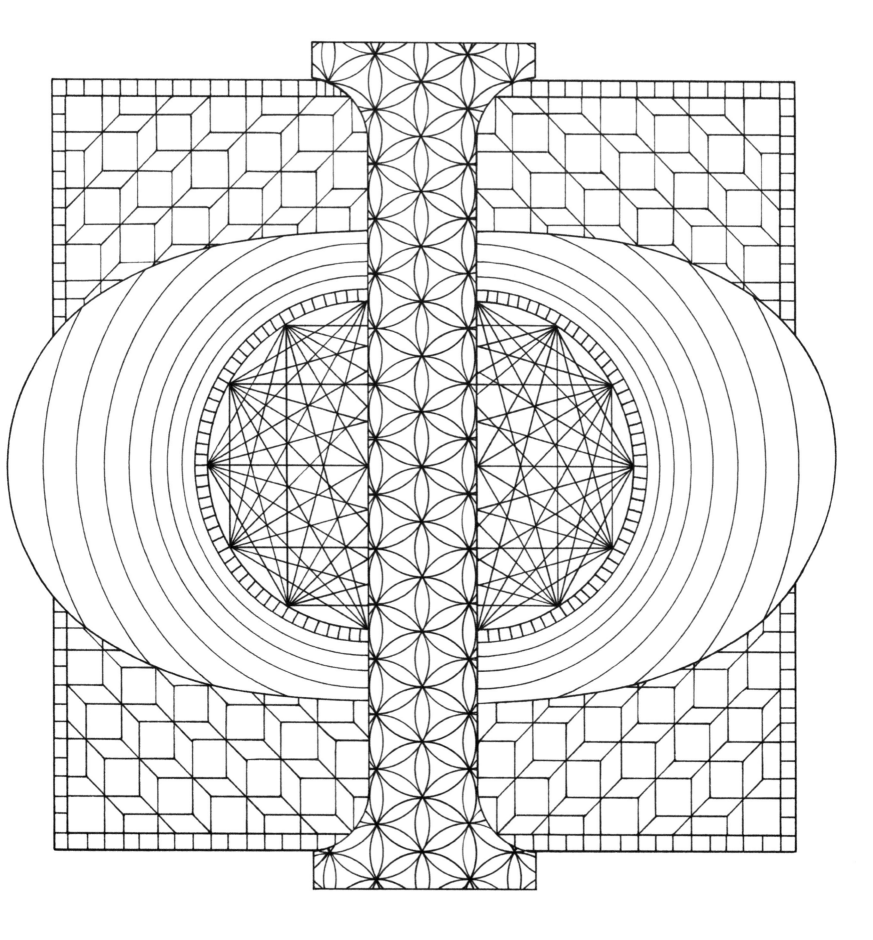

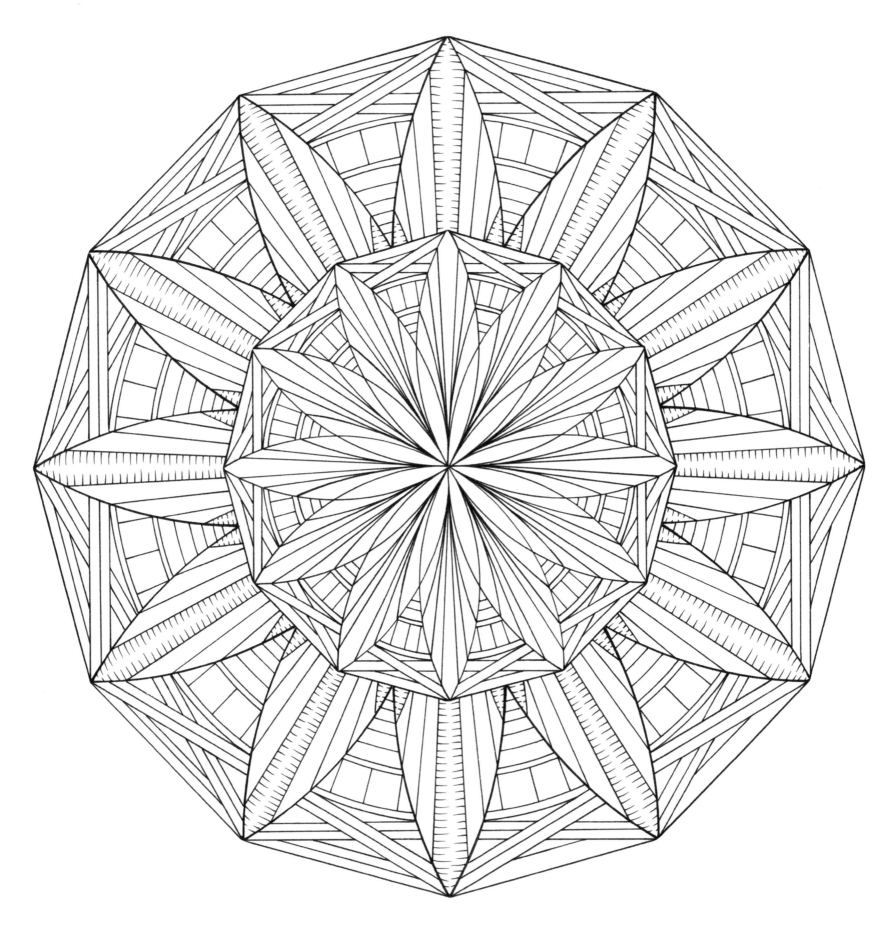

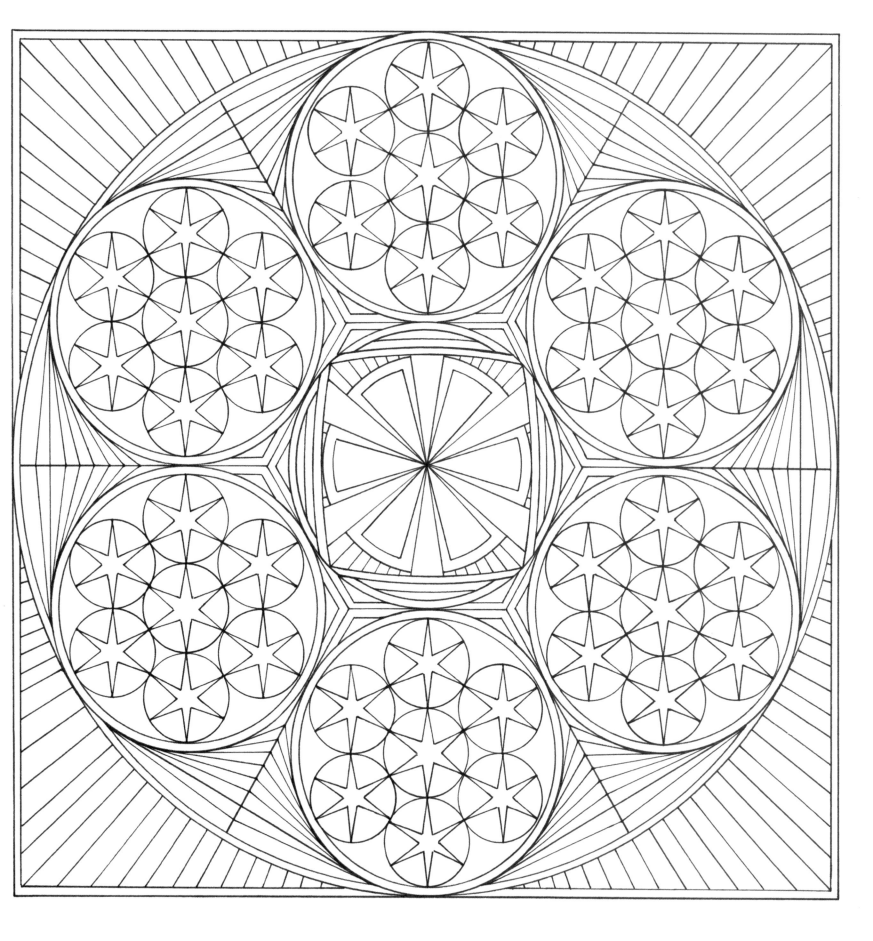

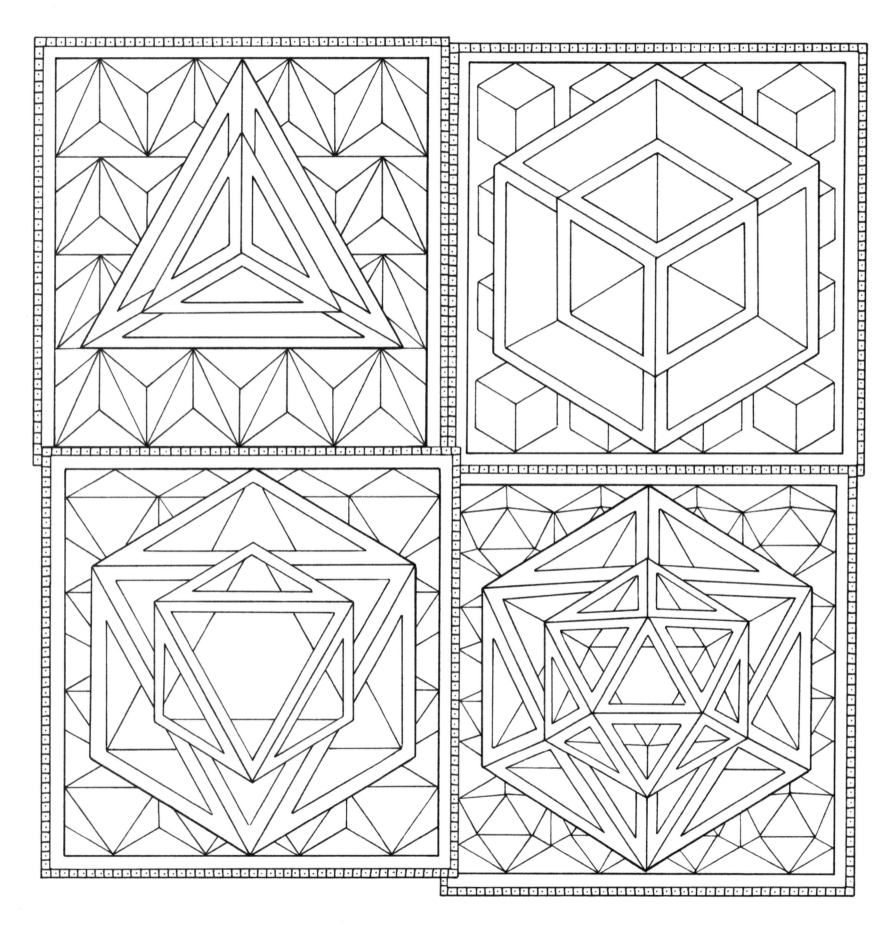

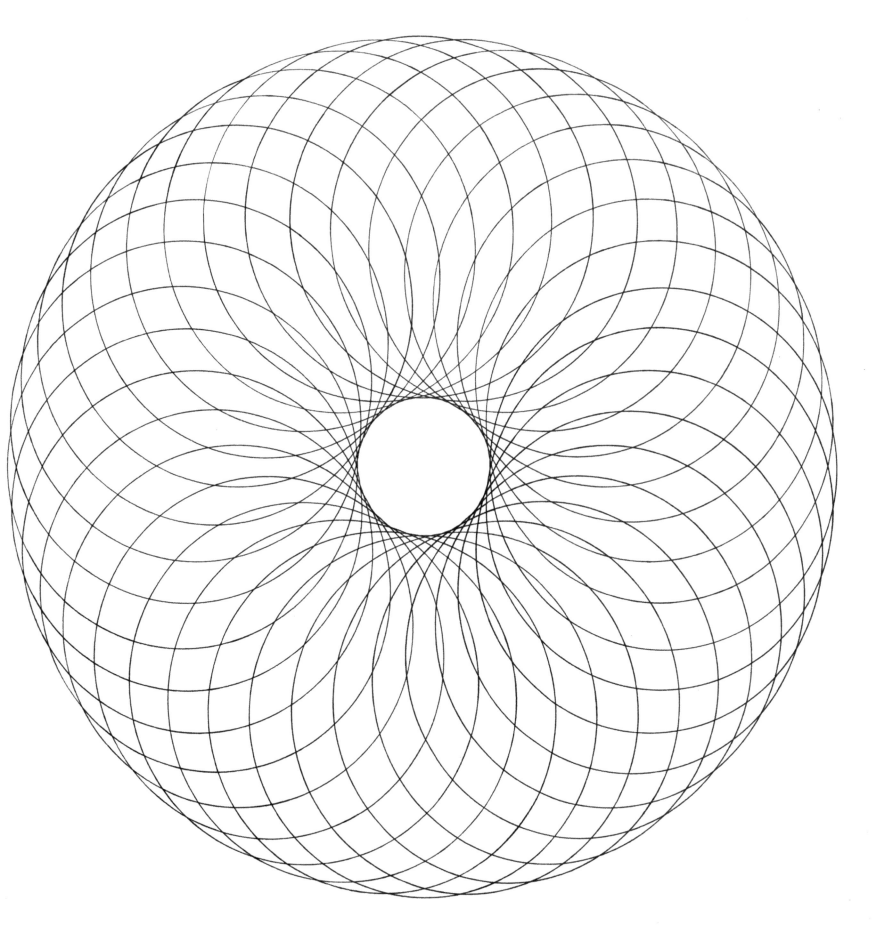

THE VESICA PISCIS

If we draw two circles, each of which has its center on the perimeter of the other, the overlapping slice is known as the "vesica piscis," or the "Jesus fish." This is a symbol that has been widely used in Christian, Kabbalistic, and Islamic art and architecture (for instance, in the shape of Gothic arches), and is the most basic building block of the Flower of Life.

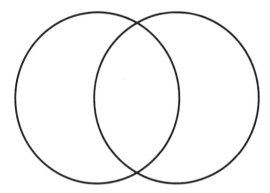

Pythagoreans saw this image as representing the intersection between the divine and the material, and studied it for its geometrical qualities. In the image below, for example, if you divide the circle into six equal slices, two sides of the shaded triangle form the sides of one "slice."

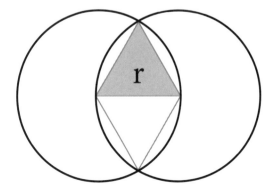

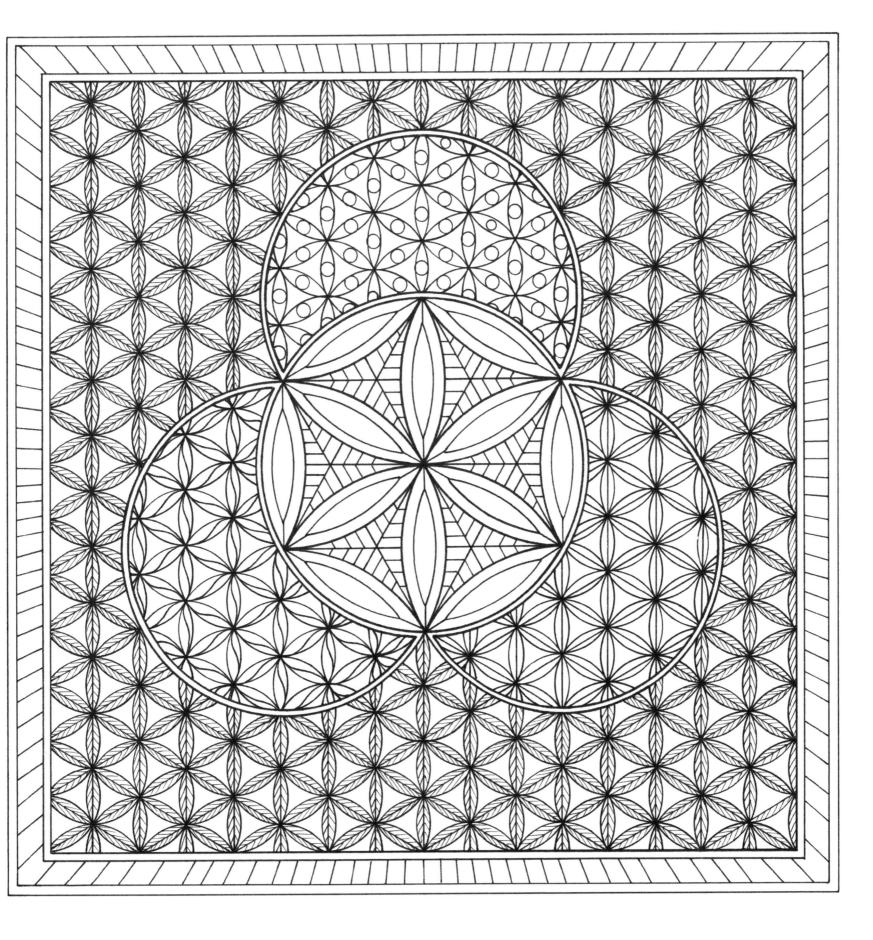

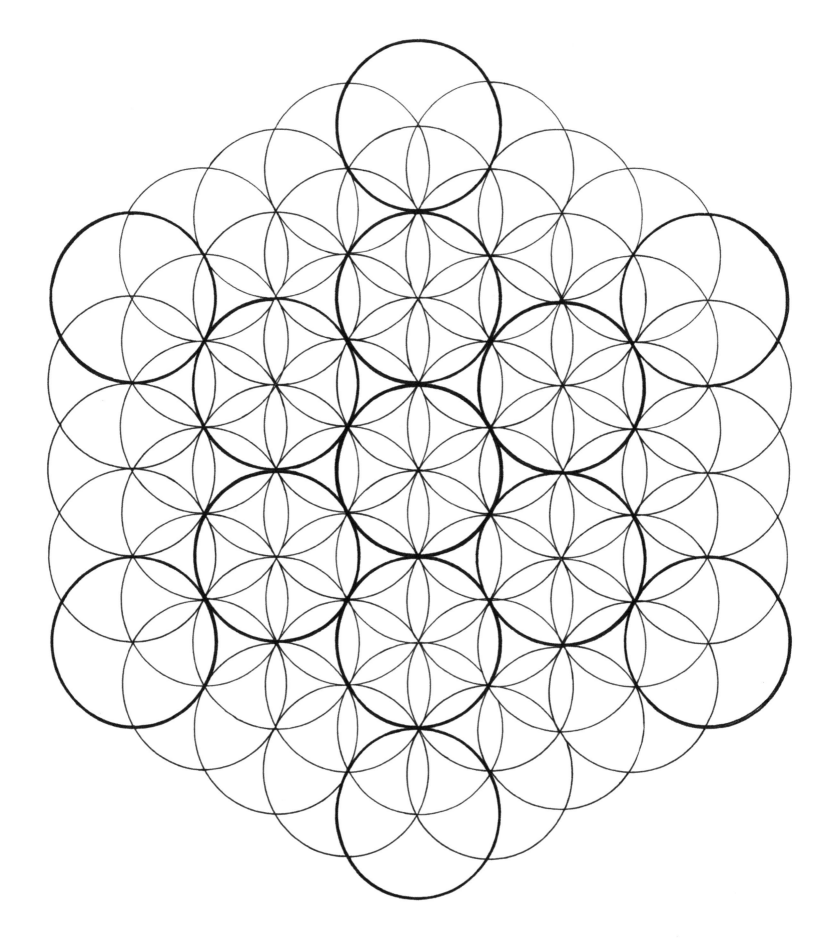

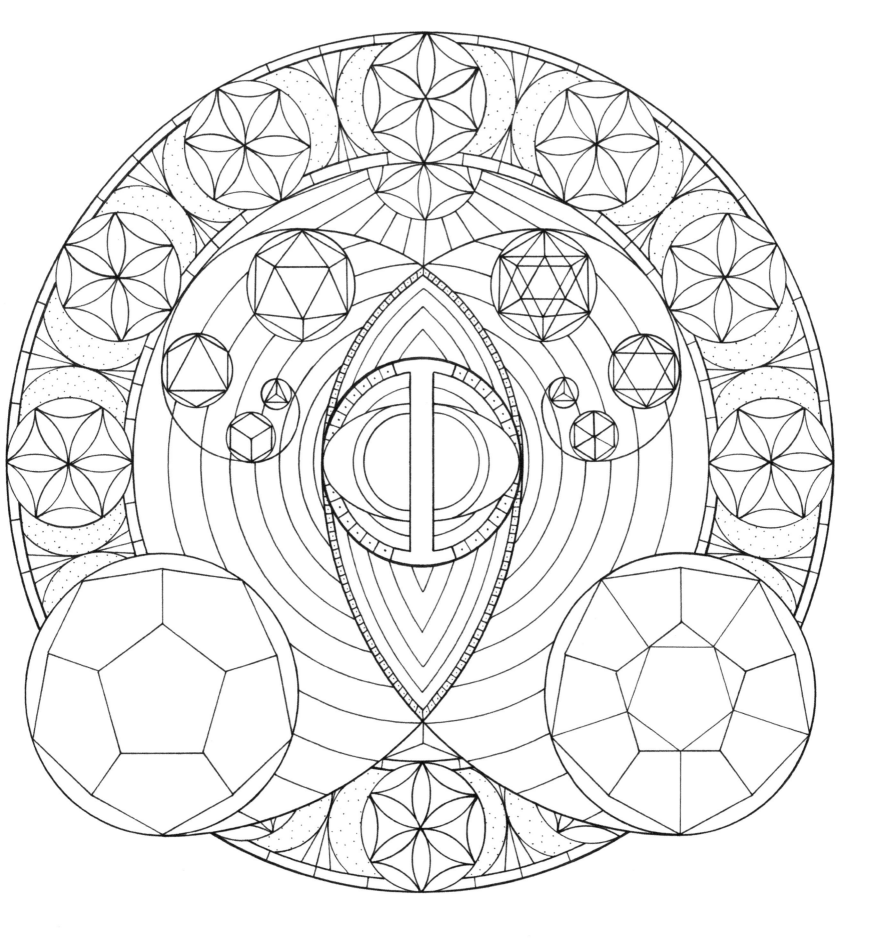

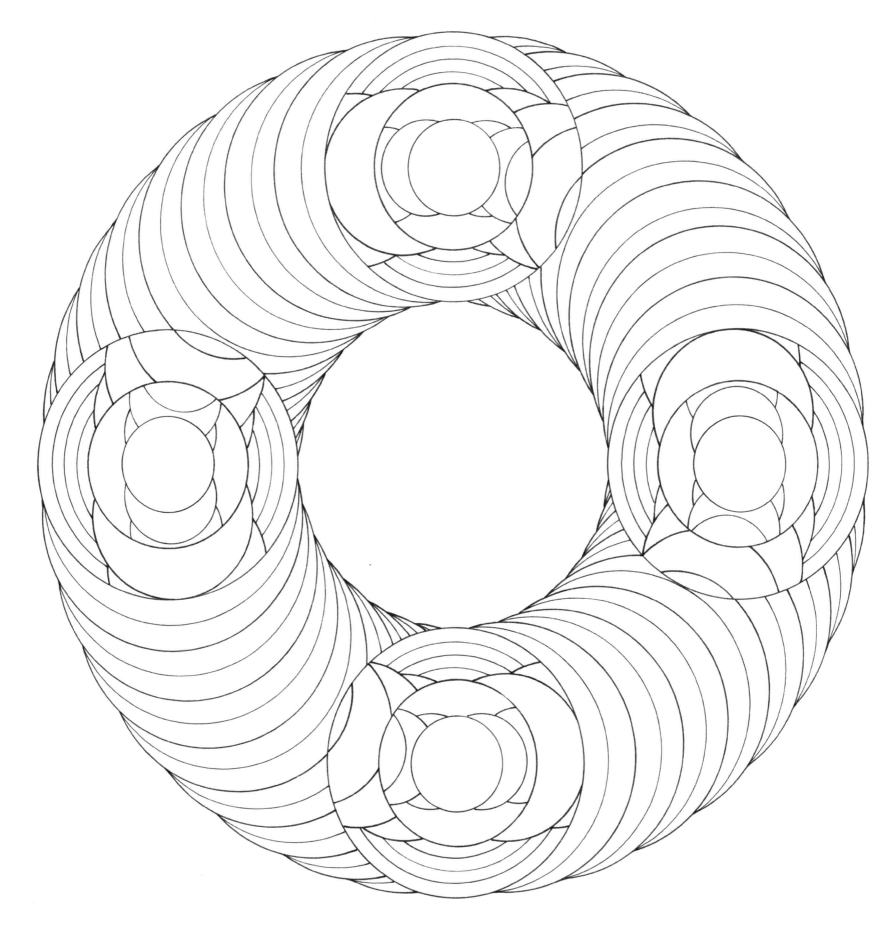

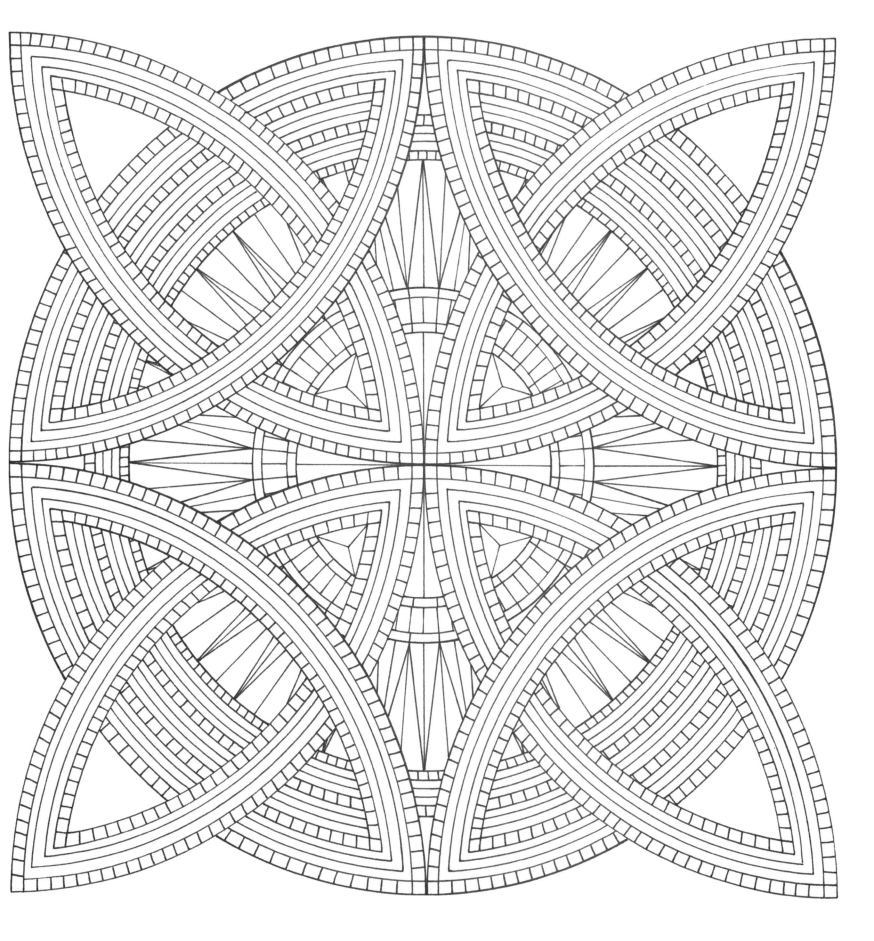

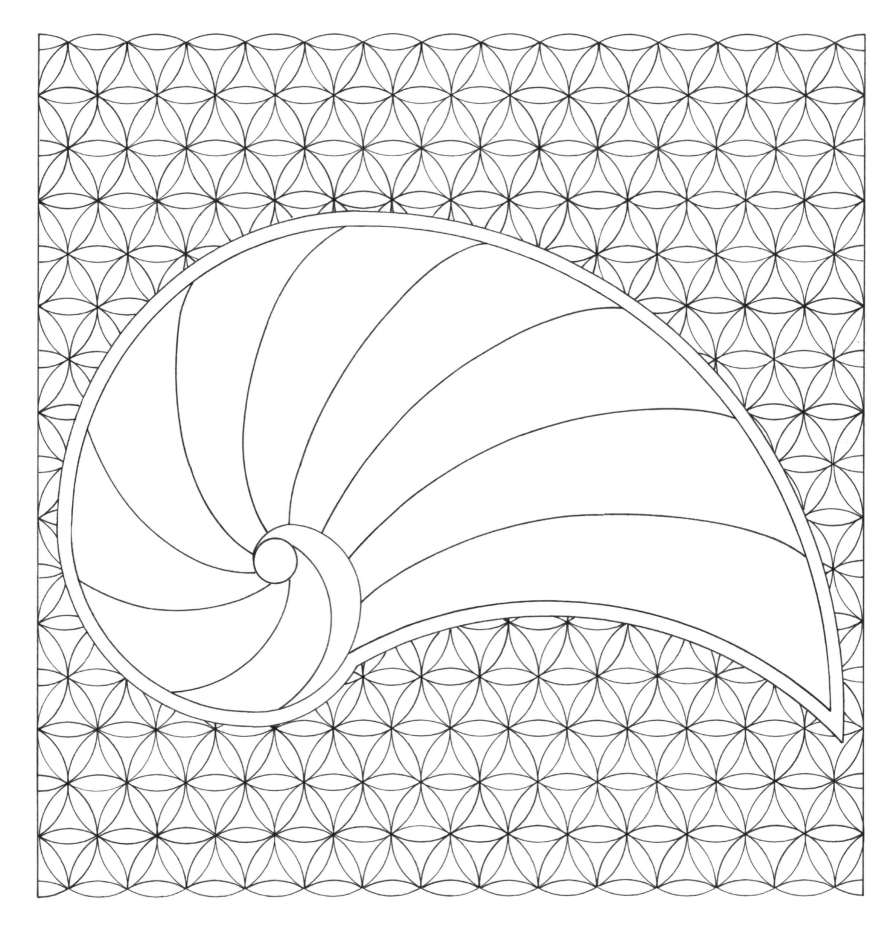

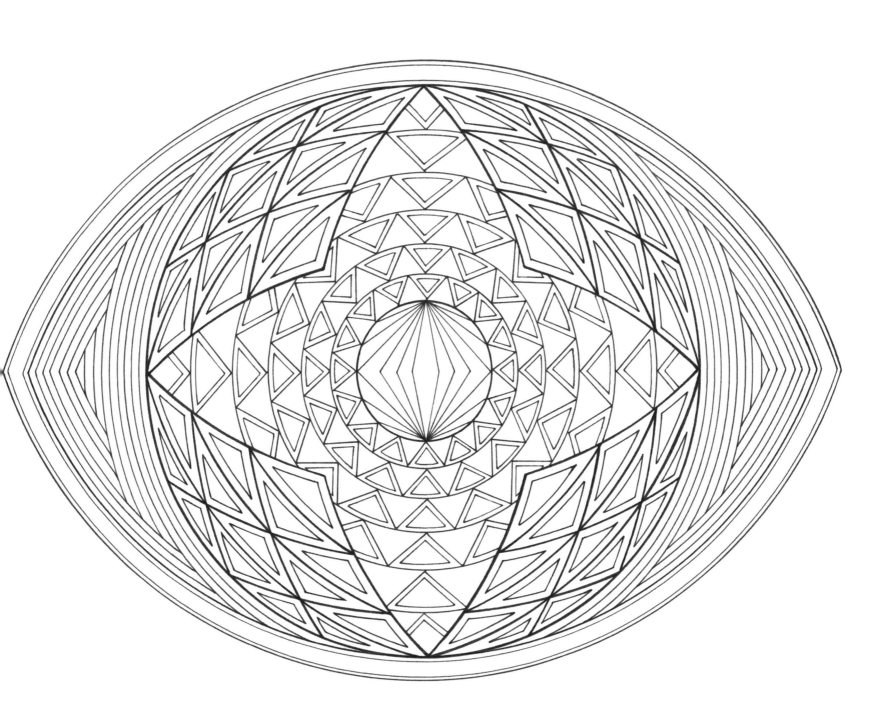

THE FLOWER OF LIFE

The Flower of Life is a geometrical pattern using evenly
spaced, overlapping circles. The center of each circle touches
the perimeter of six surrounding circles, and this creates
the classic flower pattern. Many have ascribed spiritual or
sacred powers to the Flower. For instance, in Kabbalah
teachings it is emphasized that you can find related patterns
such as the Tree of Life and the Seed of Life within the
Flower. Others have been fascinated by the mathematical
qualities of the Flower of Life. It is, for example, possible to
find versions of the five Platonic solids within the pattern.

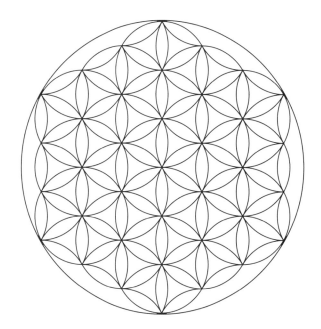

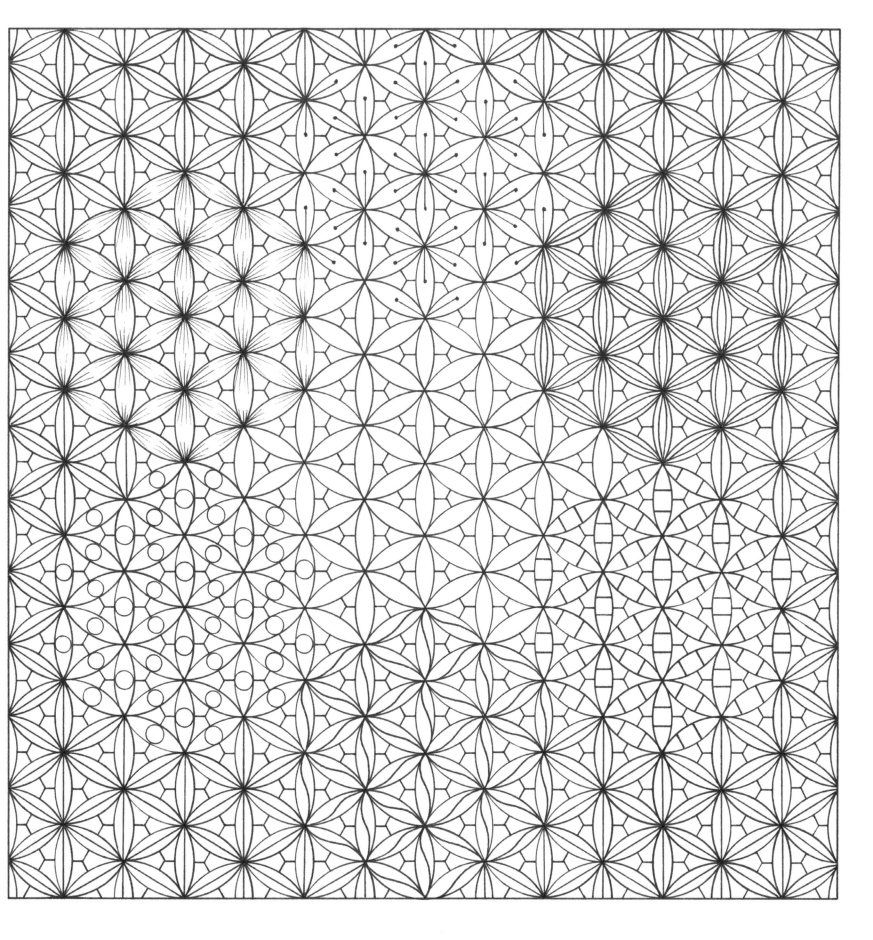

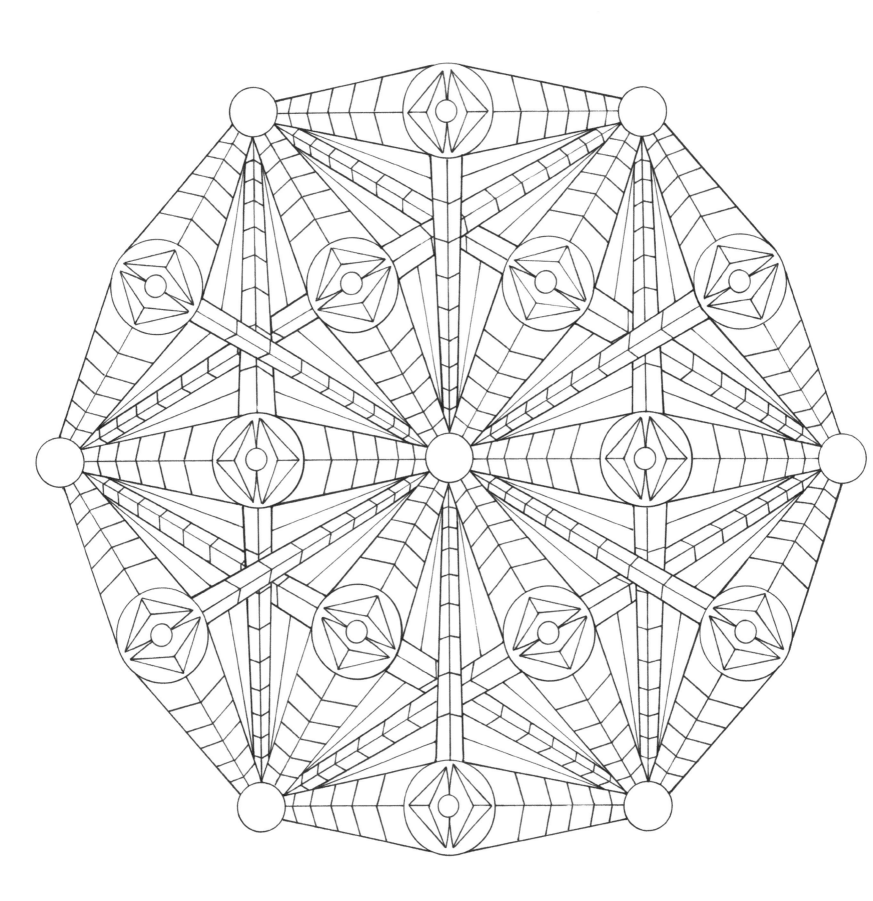

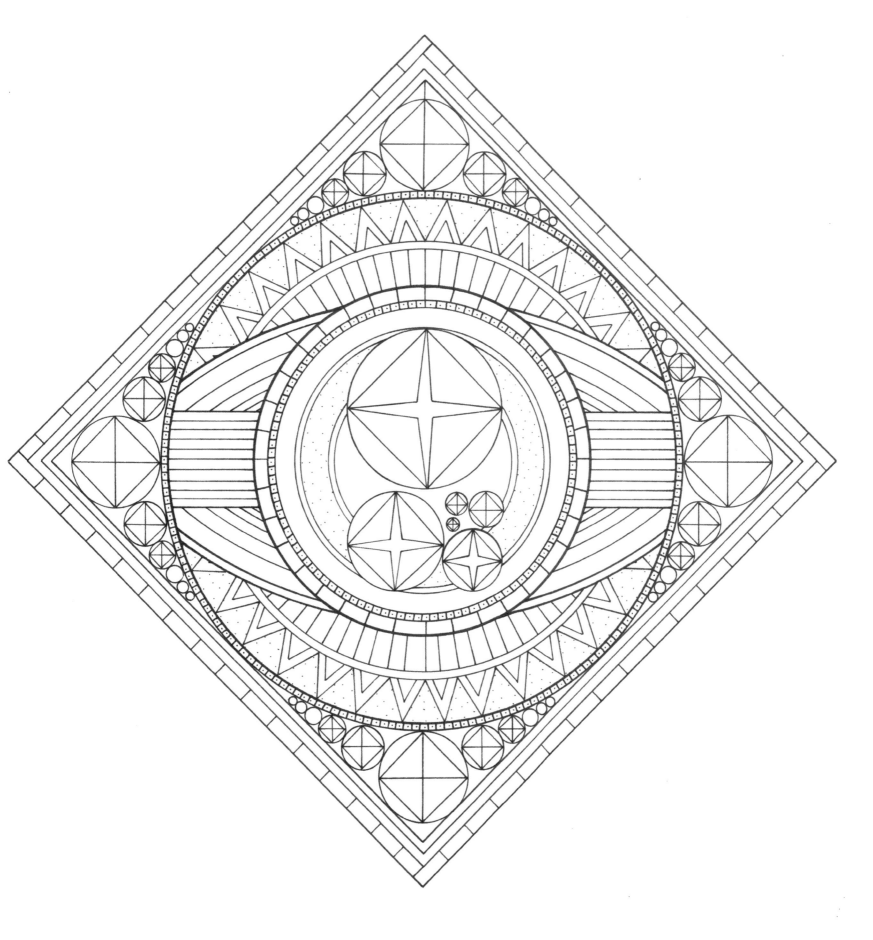

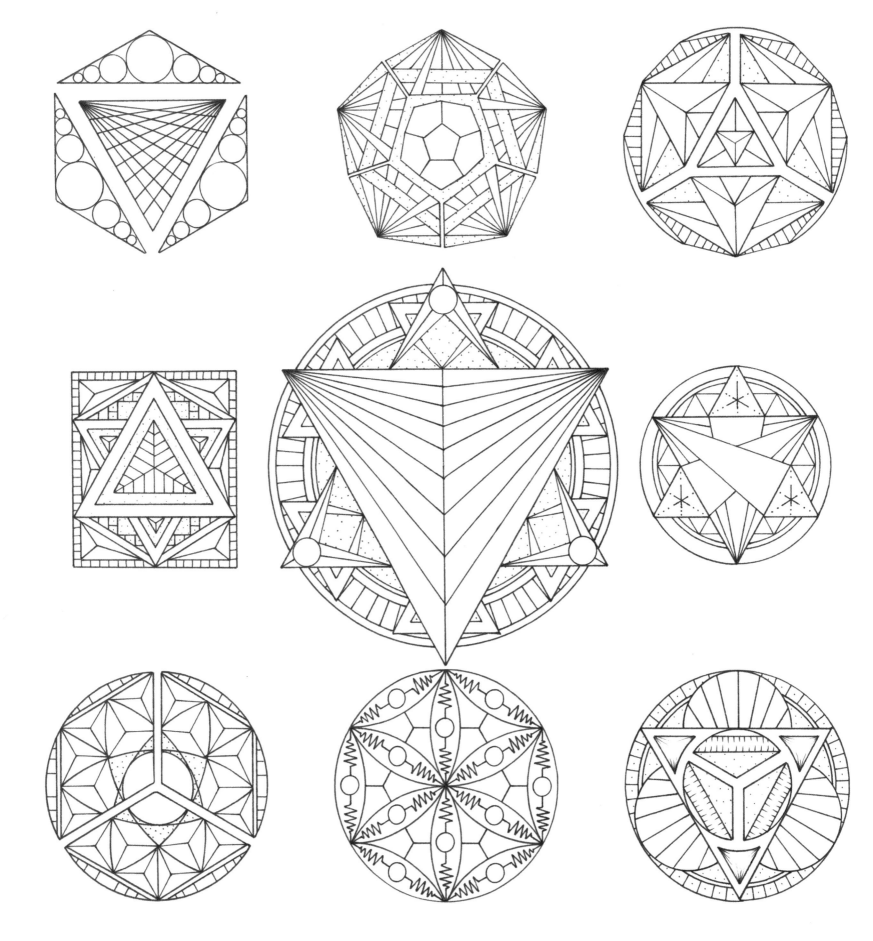

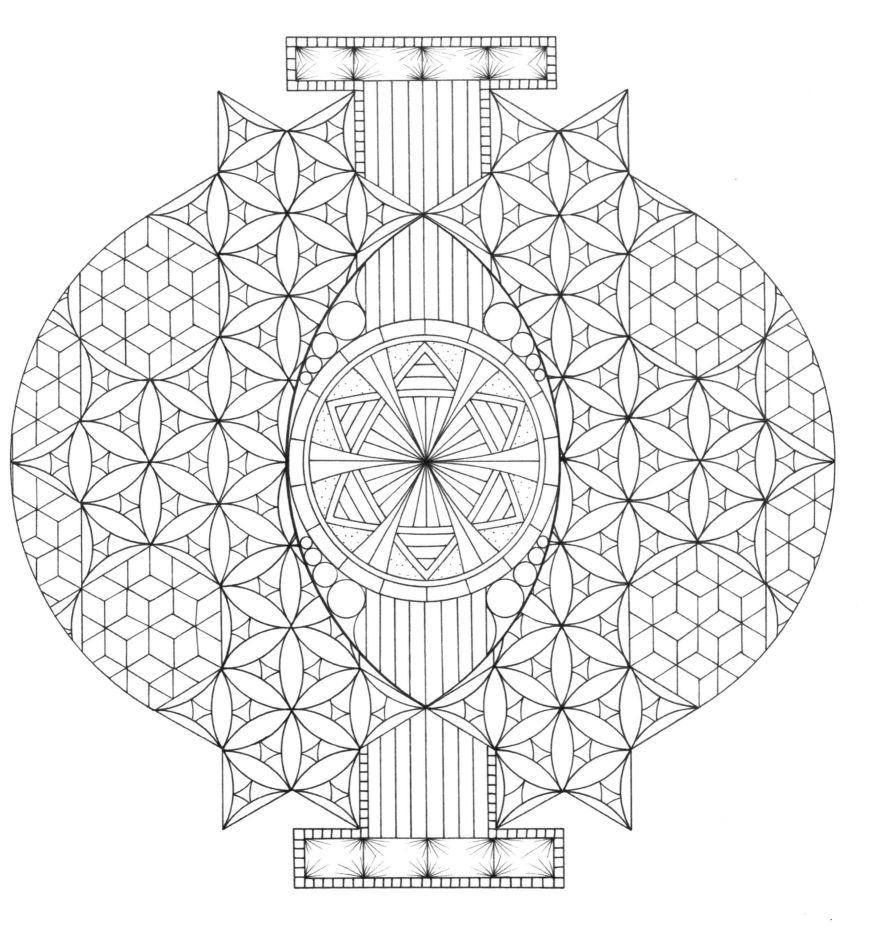

SNOWFLAKE MANDALA

A mandala is a sacred design that has often been used
to represent the cosmos, especially in Indian religions.
(The word *mandala* comes from the Sanskrit word for
circle.) Similar patterns can be found in a wide variety of
settings, such as in sand paintings by Hopi Indians, African
art, military insignia, and modern computer icons.

Real snowflakes tend to have six-fold rotational symmetry,
which simply means they come in six identical "slices"
and you can rotate them six times into the same exact
position. Opposite, six-fold symmetry has been used
to create a mandala in the image of a snowflake.

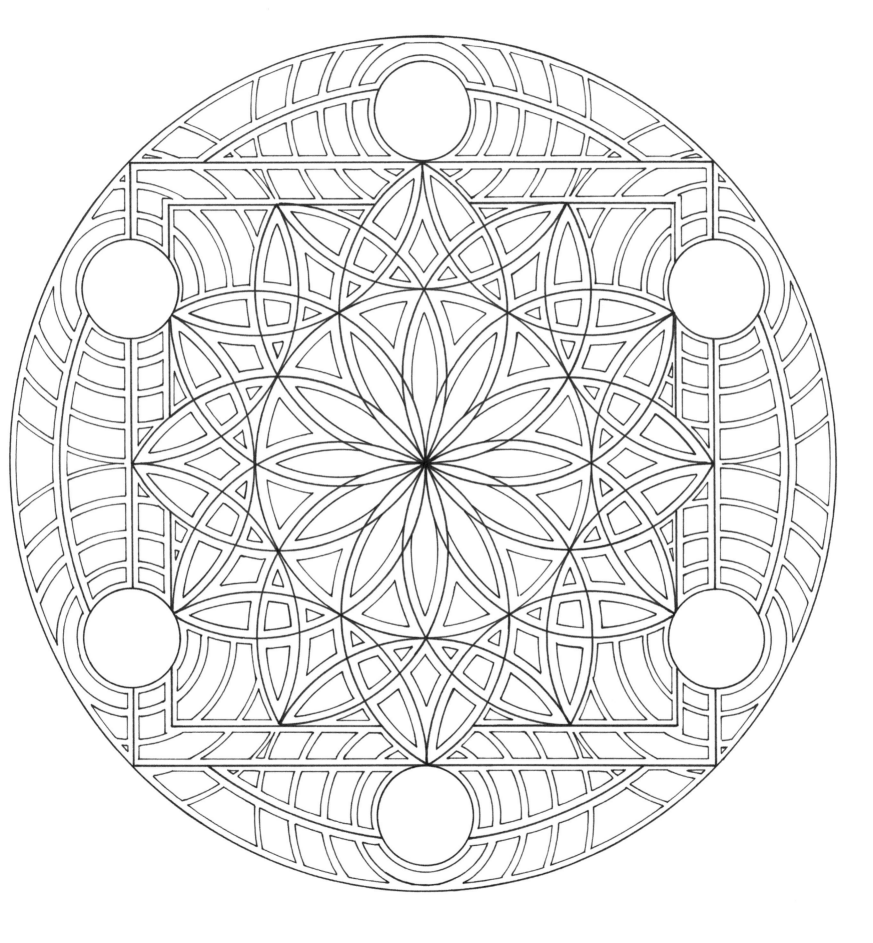

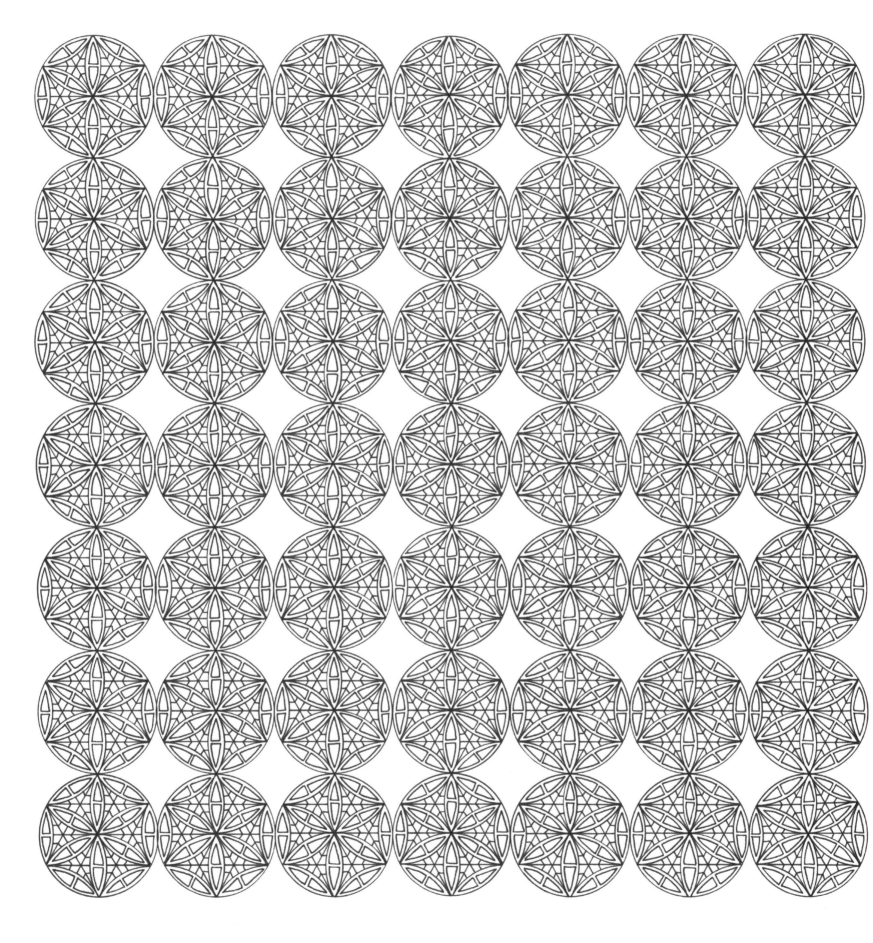

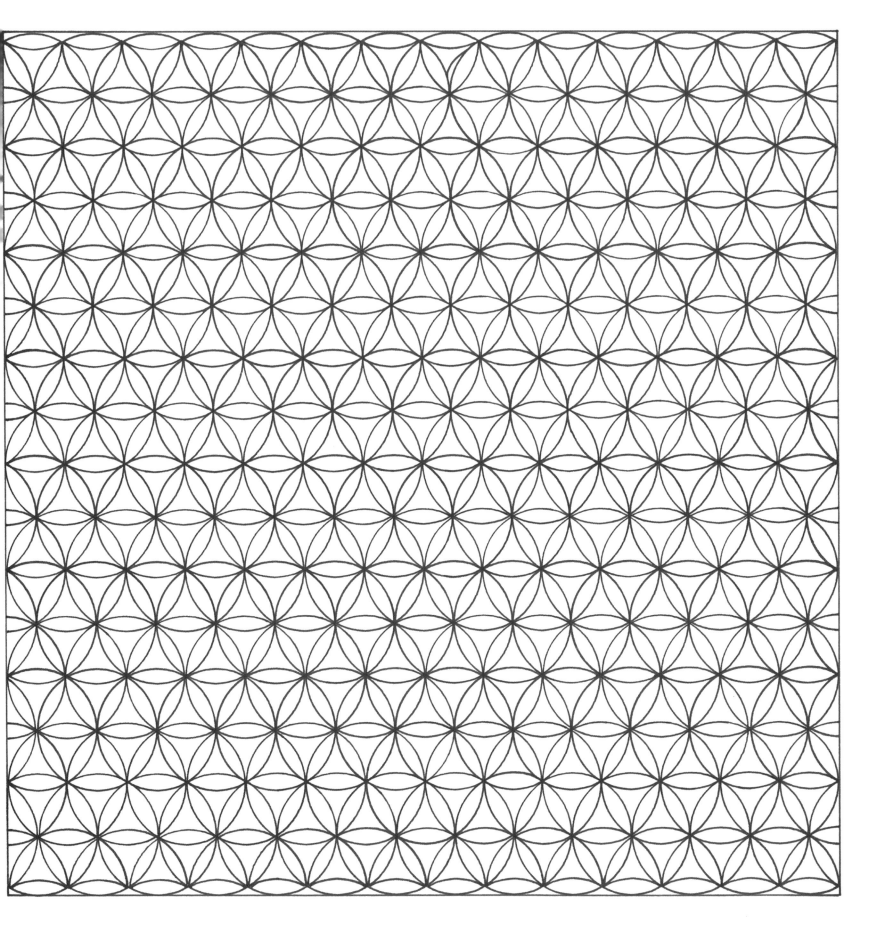

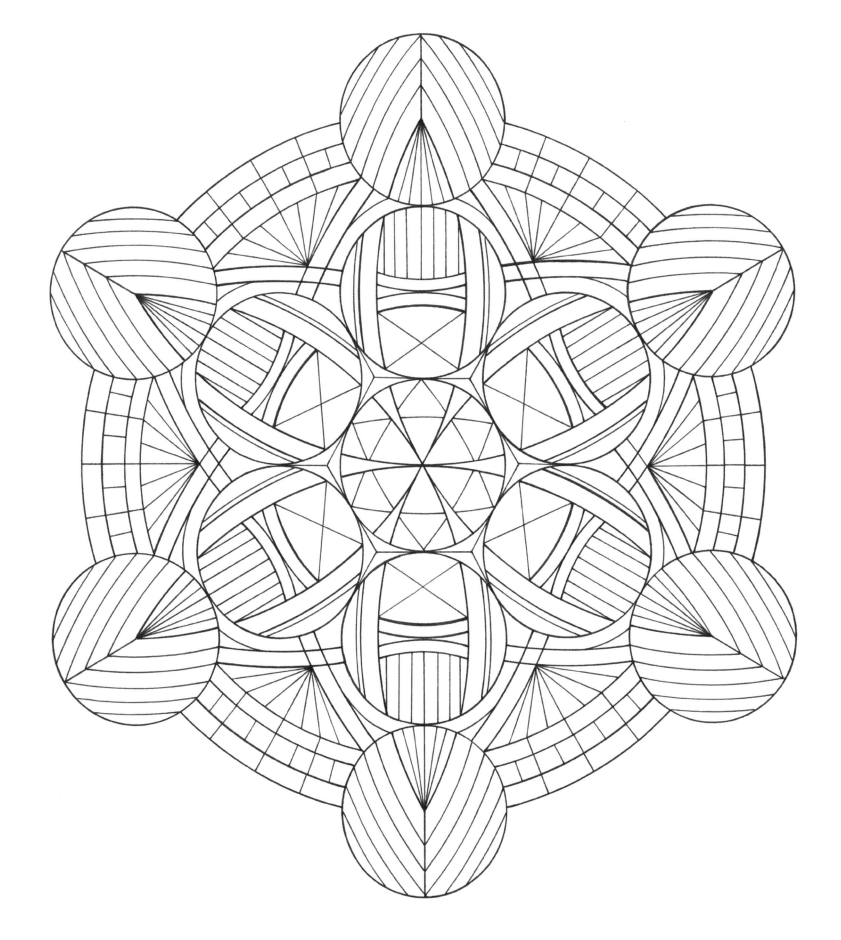

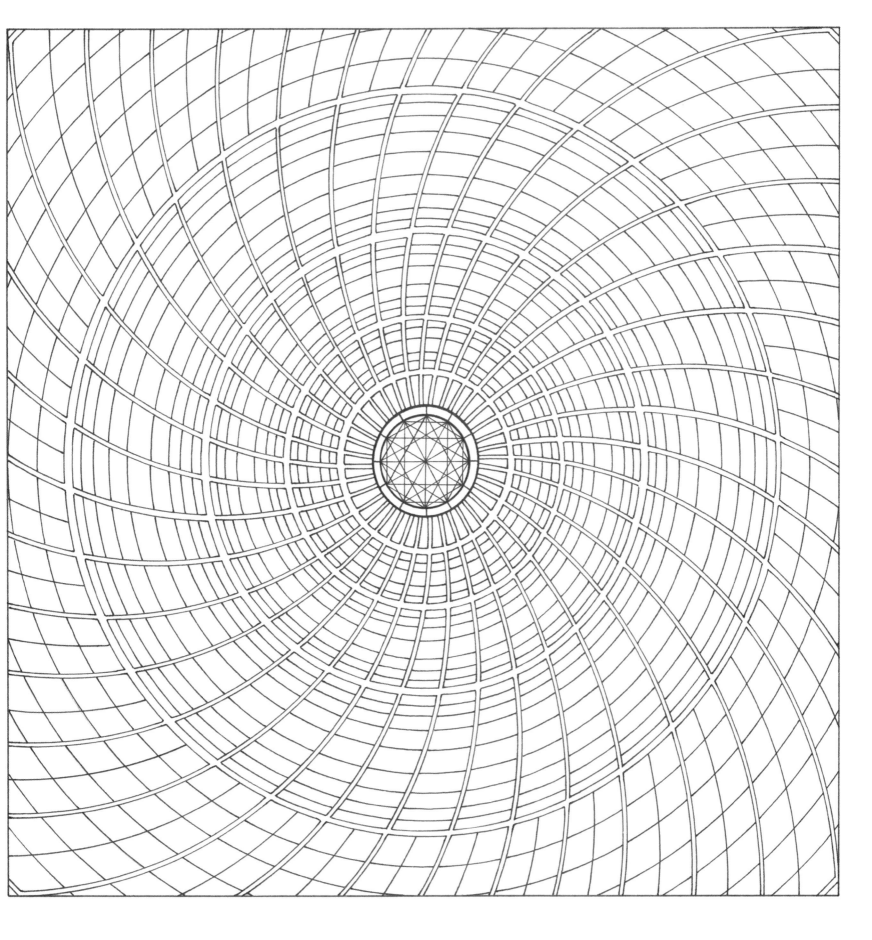

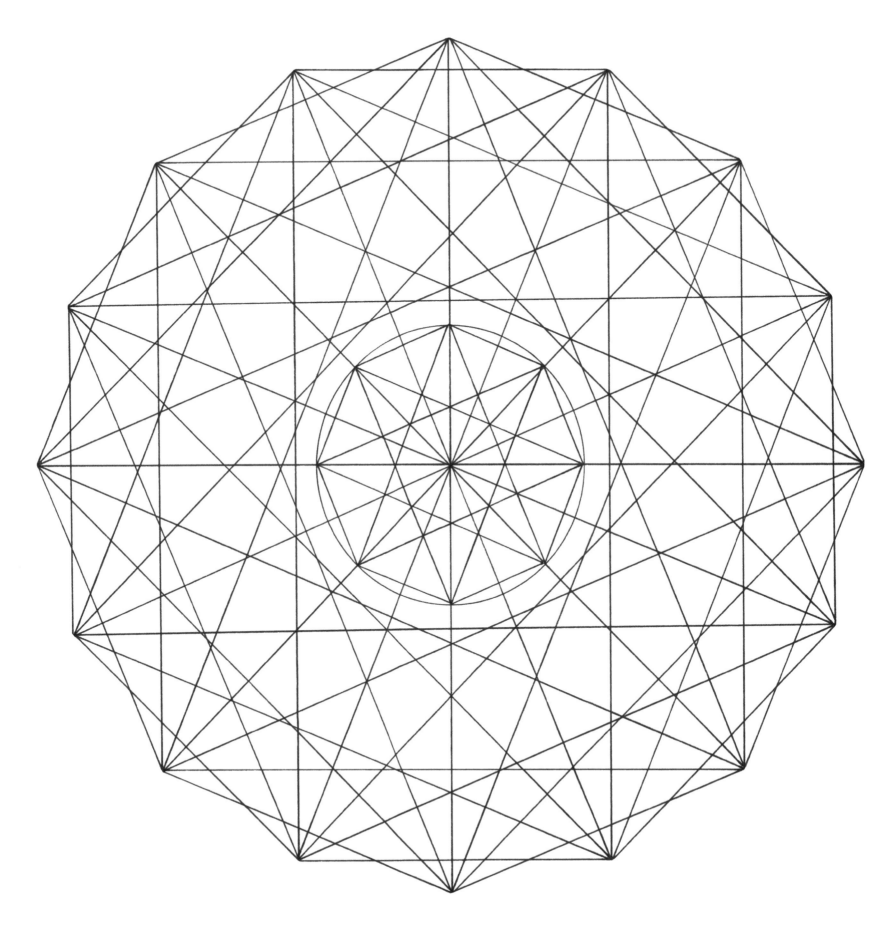

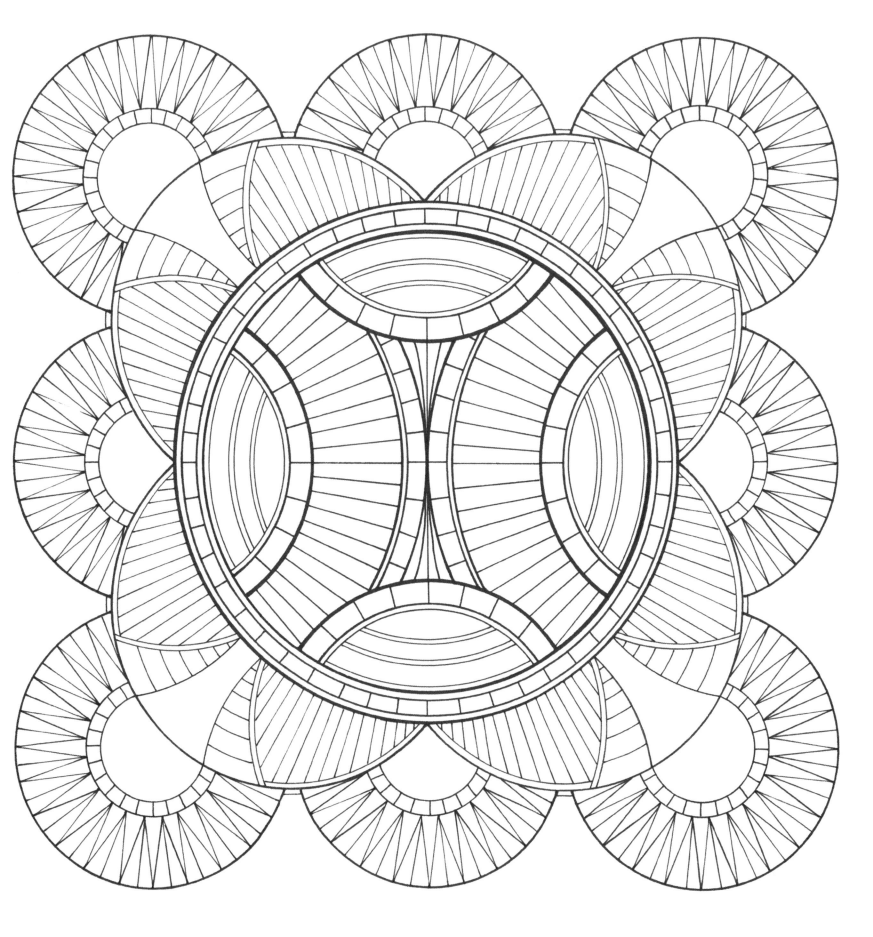

METATRON'S CUBE AND THE FRUIT OF LIFE

Ancient Greek mathematicians such as Pythagoras were among those who found the beauty of mathematical objects so profound that they felt they must reveal the underlying order of the universe. This notion can be seen in the dictum of the Pythagorean school: "All is number."

Metatron's cube (named after the archangel of religious texts) is a three-dimensional construction in which spheres piled in square layers form a cube. It has many applications; for instance, it can be used to represent the tesseract (the equivalent of a cube in four dimensions). Its two-dimensional image appears in the pattern the Fruit of Life, which is itself a variation on the Flower of Life. The connections between all of these patterns are so deep that some believe they have a greater significance than simple geometry.

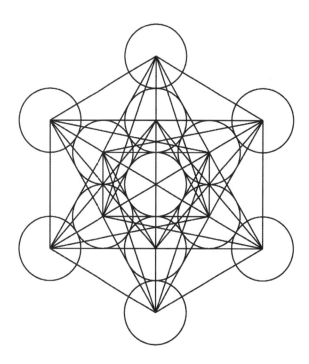

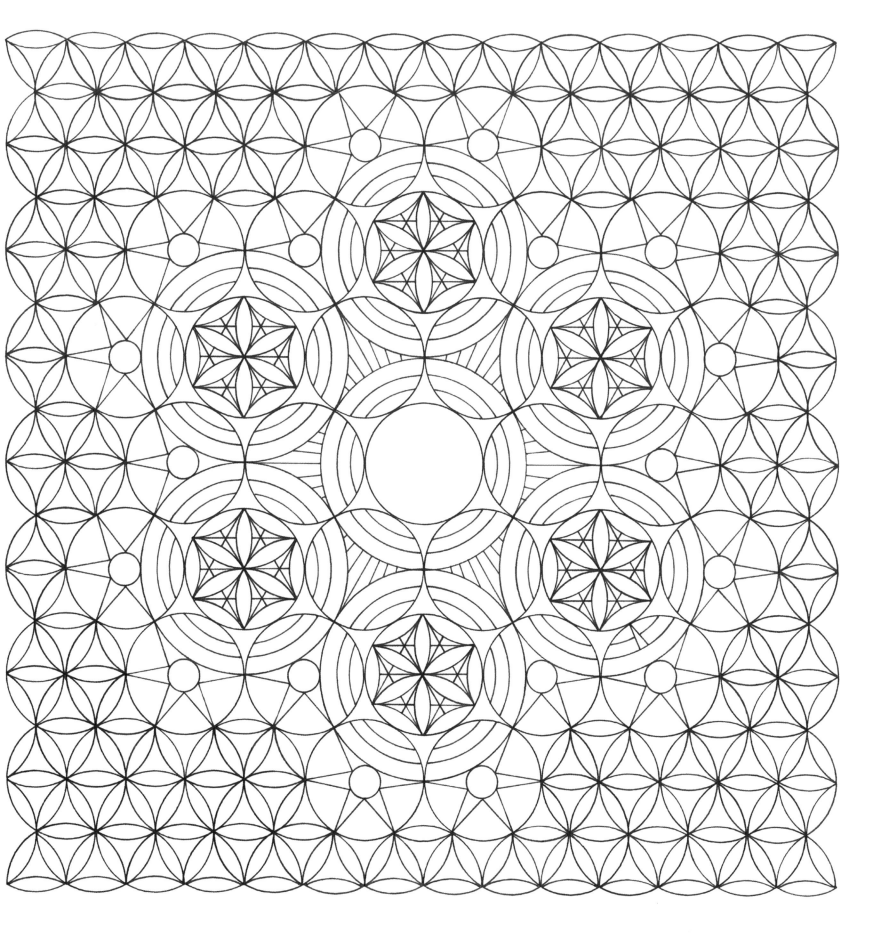

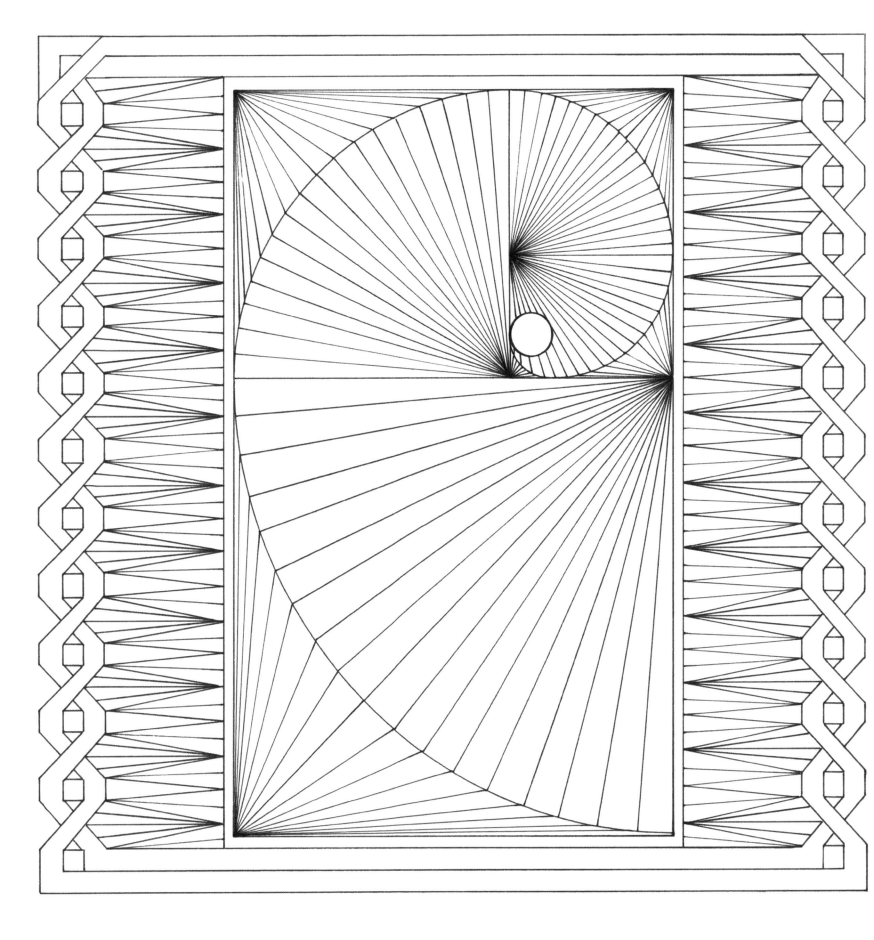

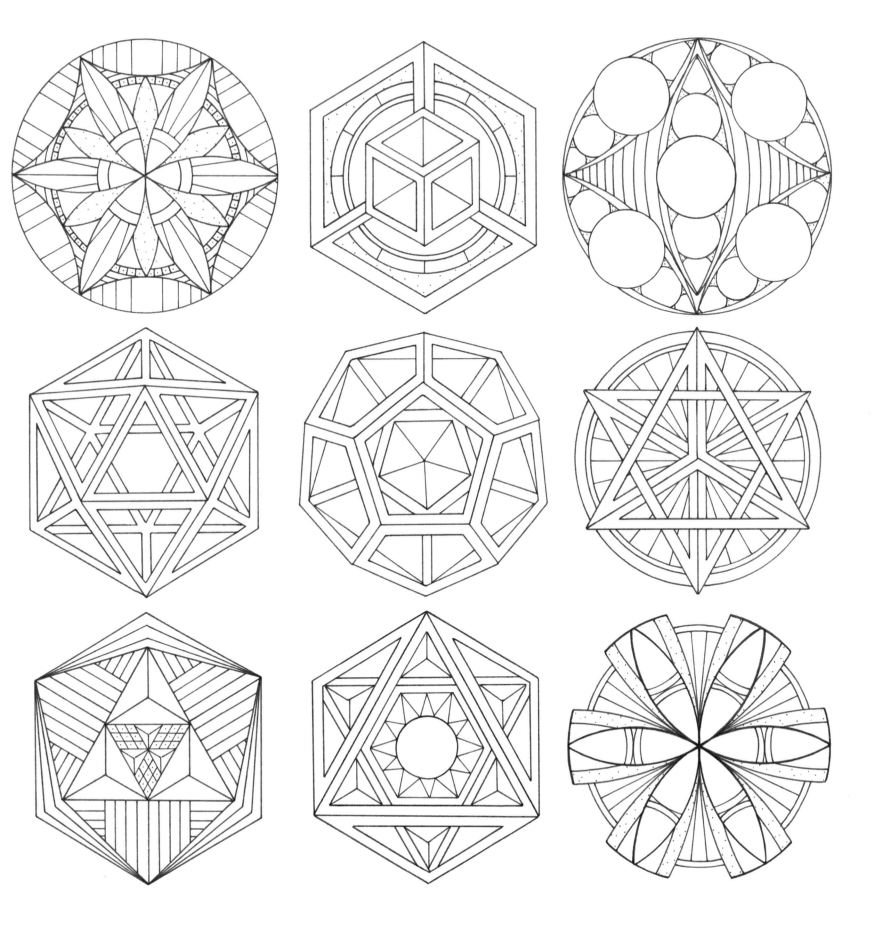

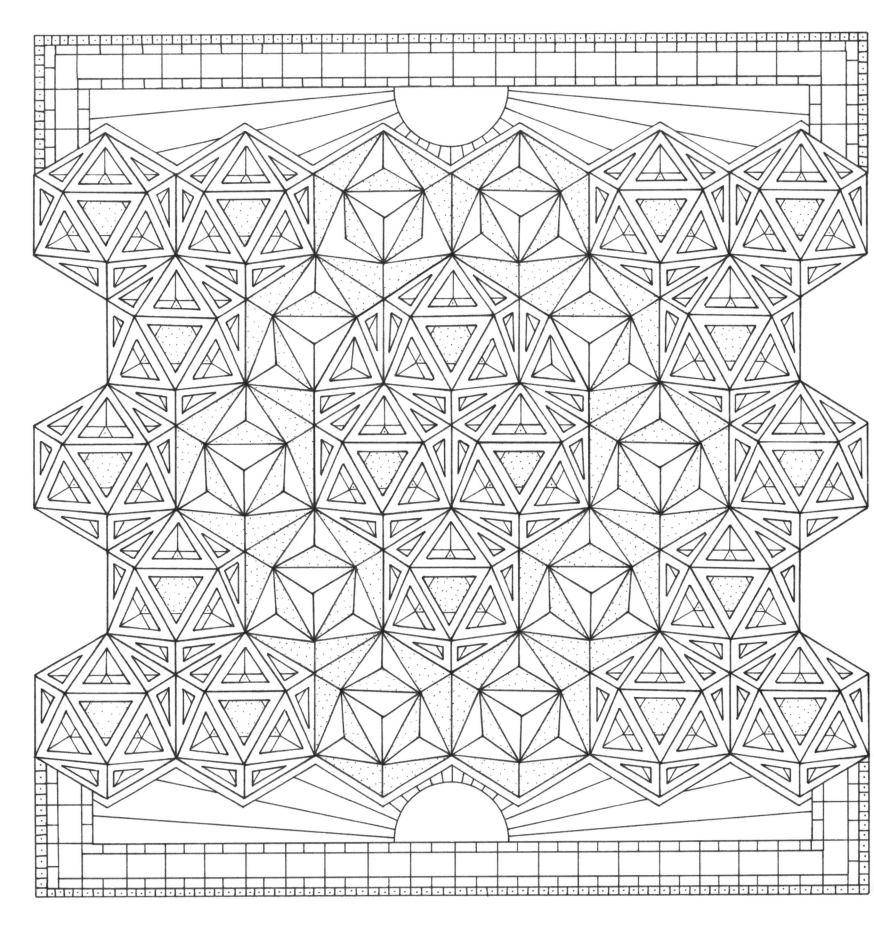

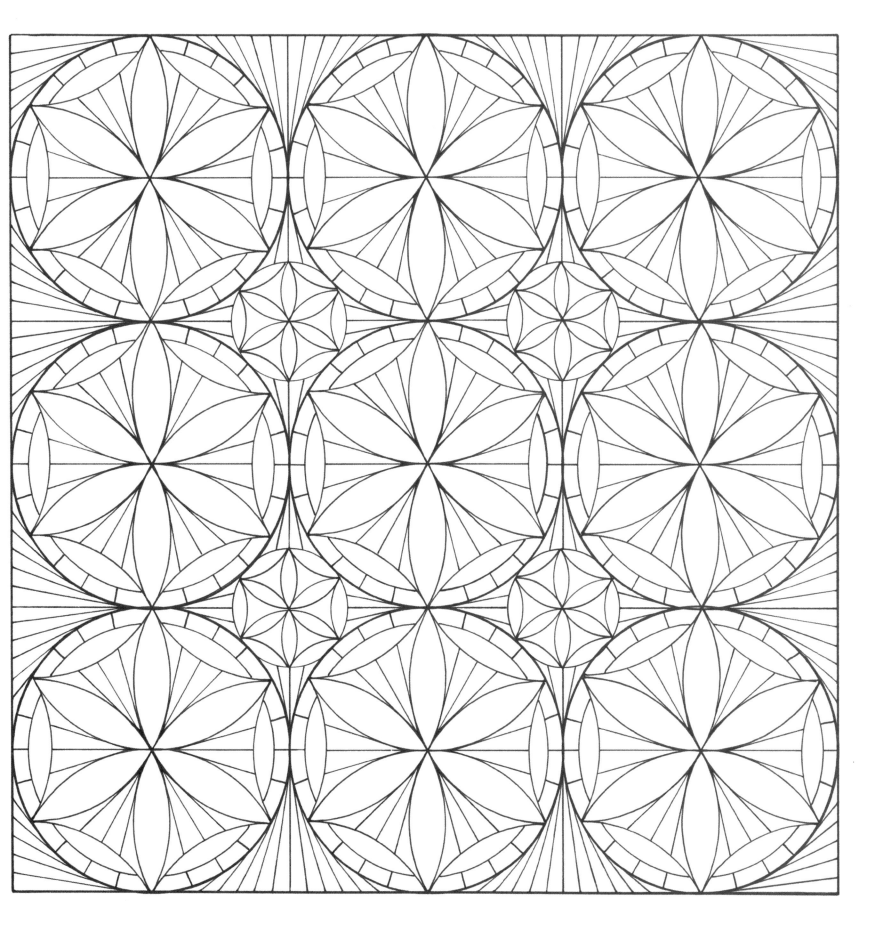

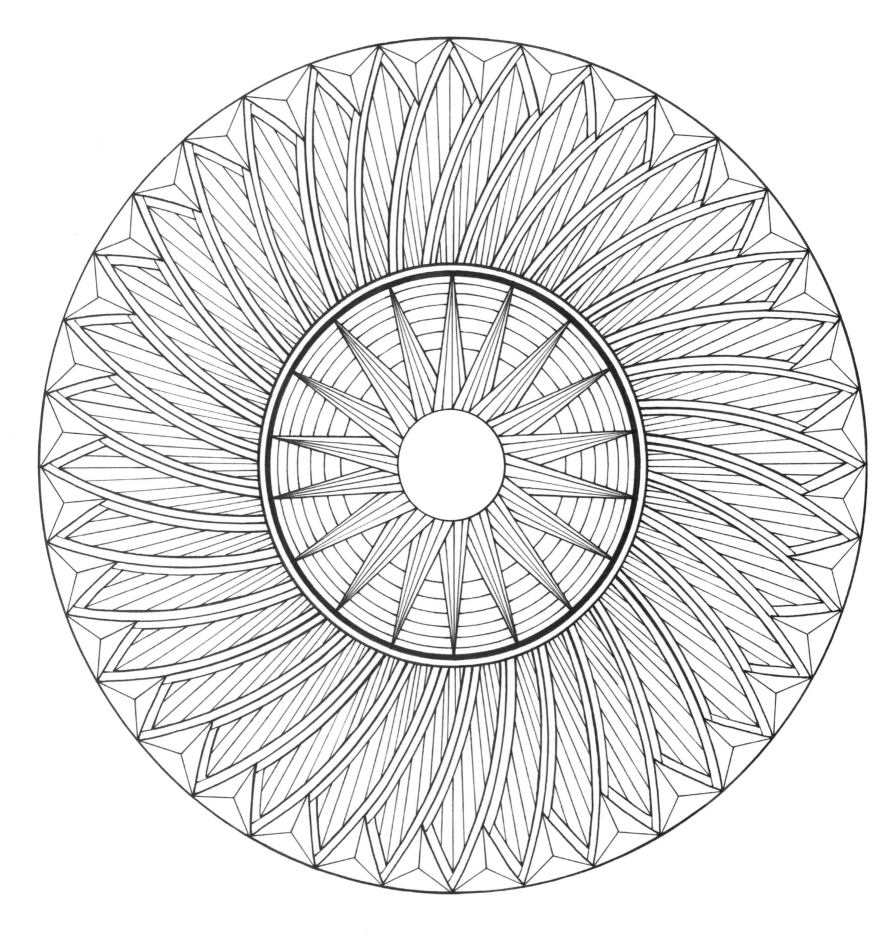

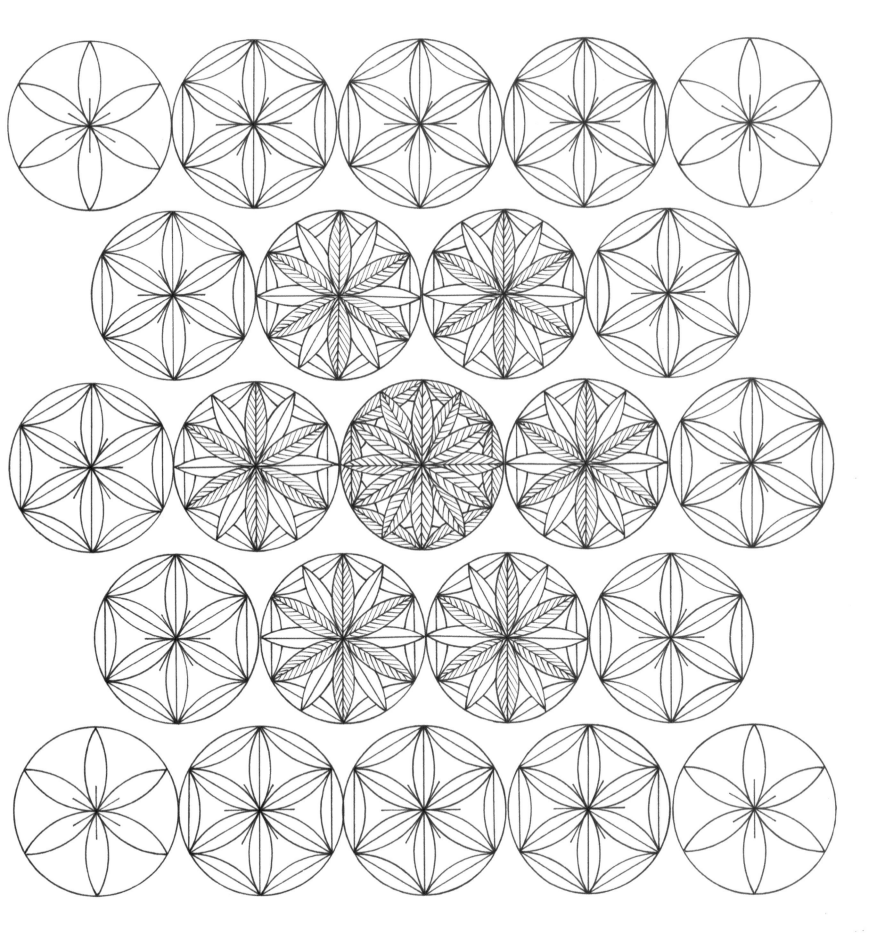

KOCH SNOWFLAKE

The Koch Snowflake was one of the earliest fractal curves to have been understood. A fractal is an object whose parts are self-similar at any level of magnification. The mathematics of fractals has become increasingly important as they play a strong role in chaos theory and thus in our understanding of irregular patterns in nature, such as weather systems or the flow of water.

To construct the Koch Snowflake, you start with a triangle, then add a triangle at the midpoint of each edge. Then you reiterate this with the increased number of edges and continue to repeat the process. After many reiterations, the edge of the object becomes increasingly complex and tiny sections of it closely resemble larger ones.

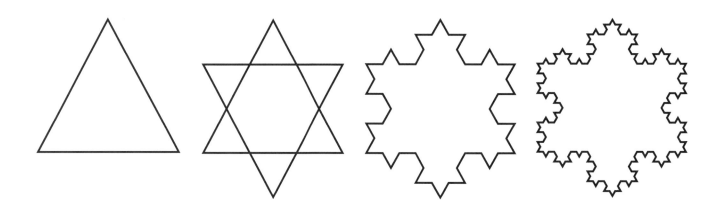

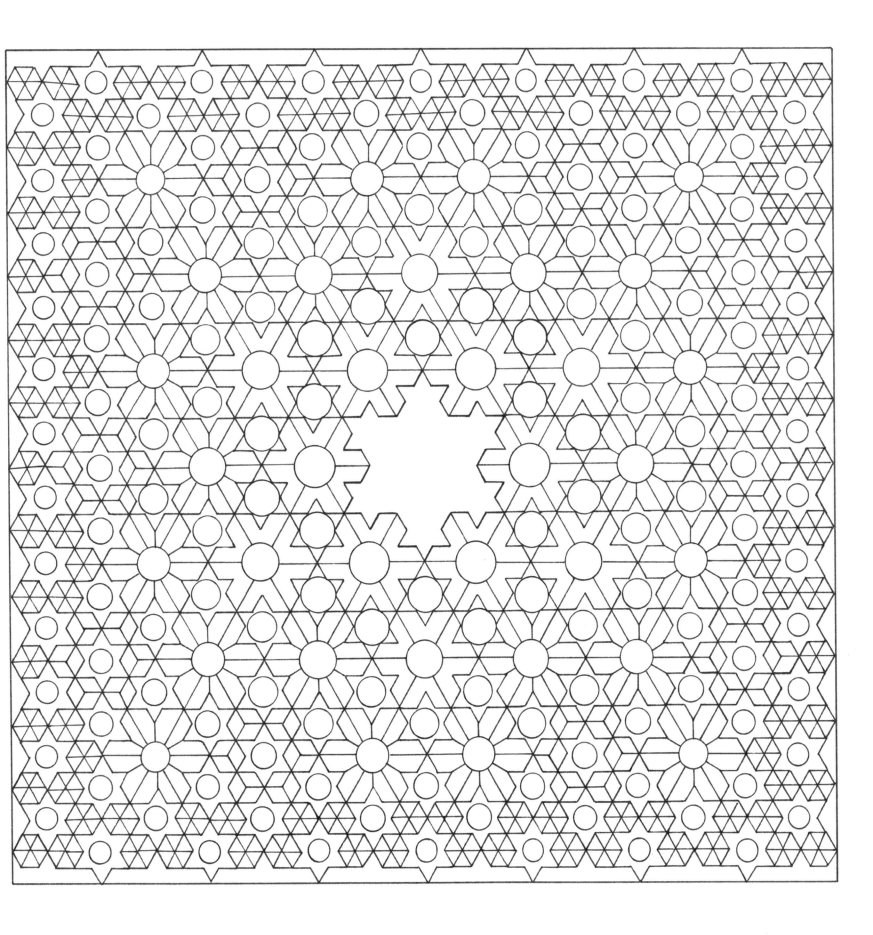

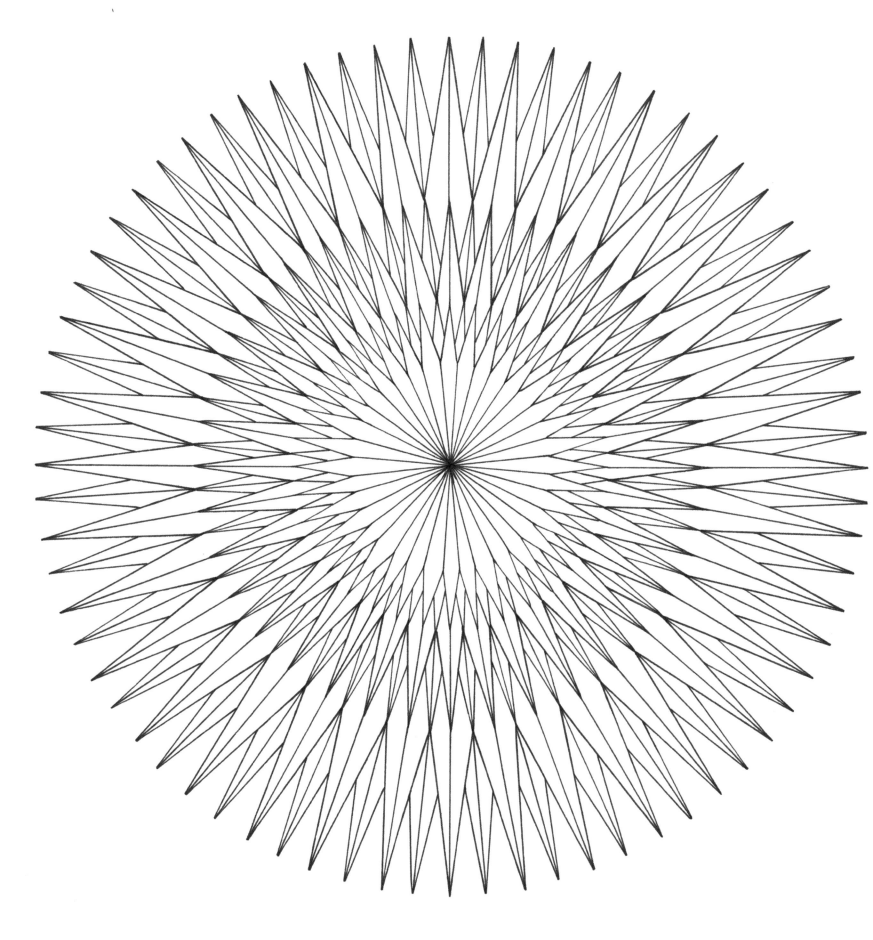

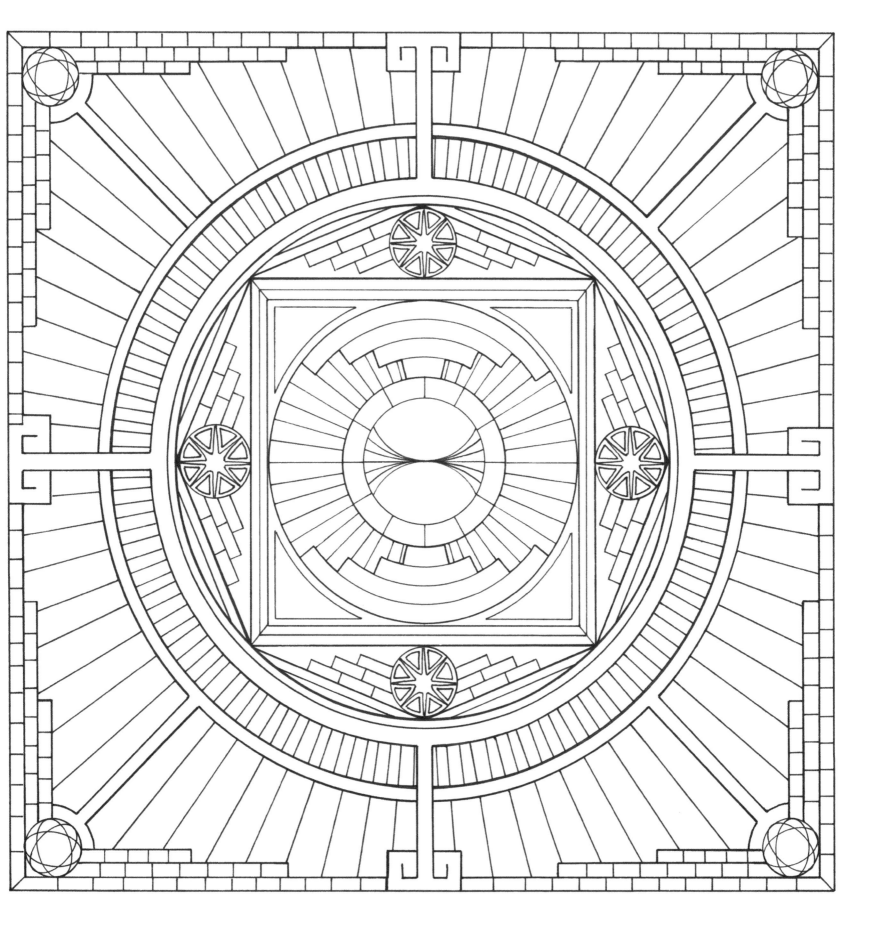

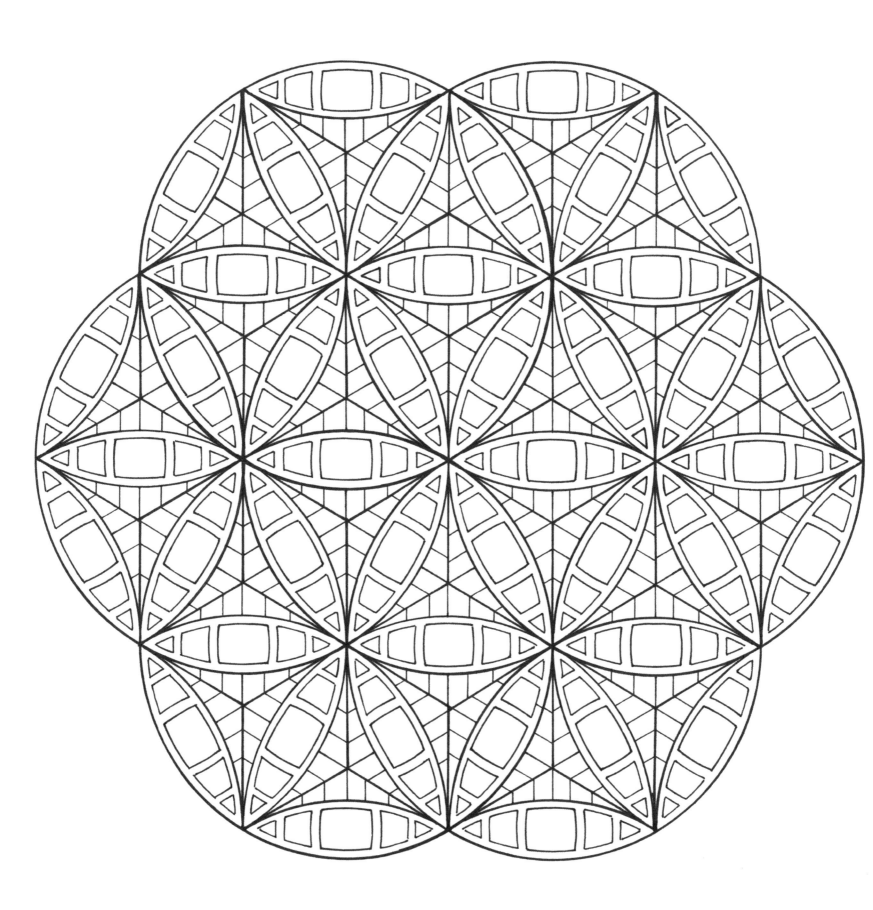

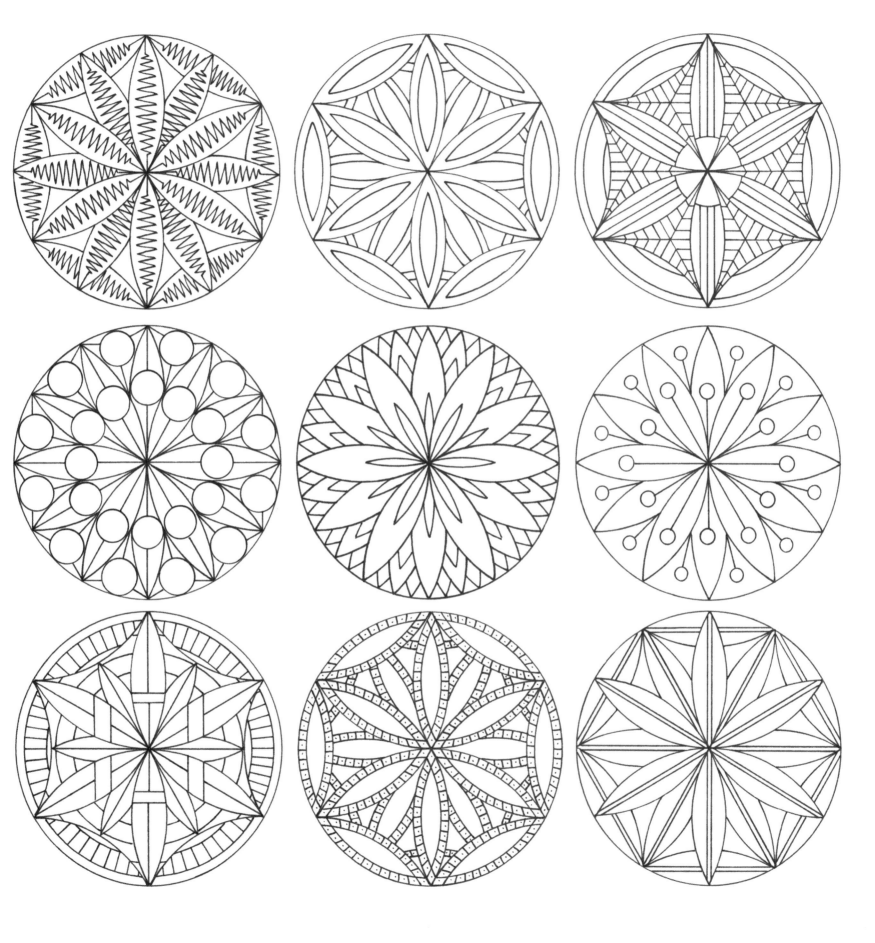

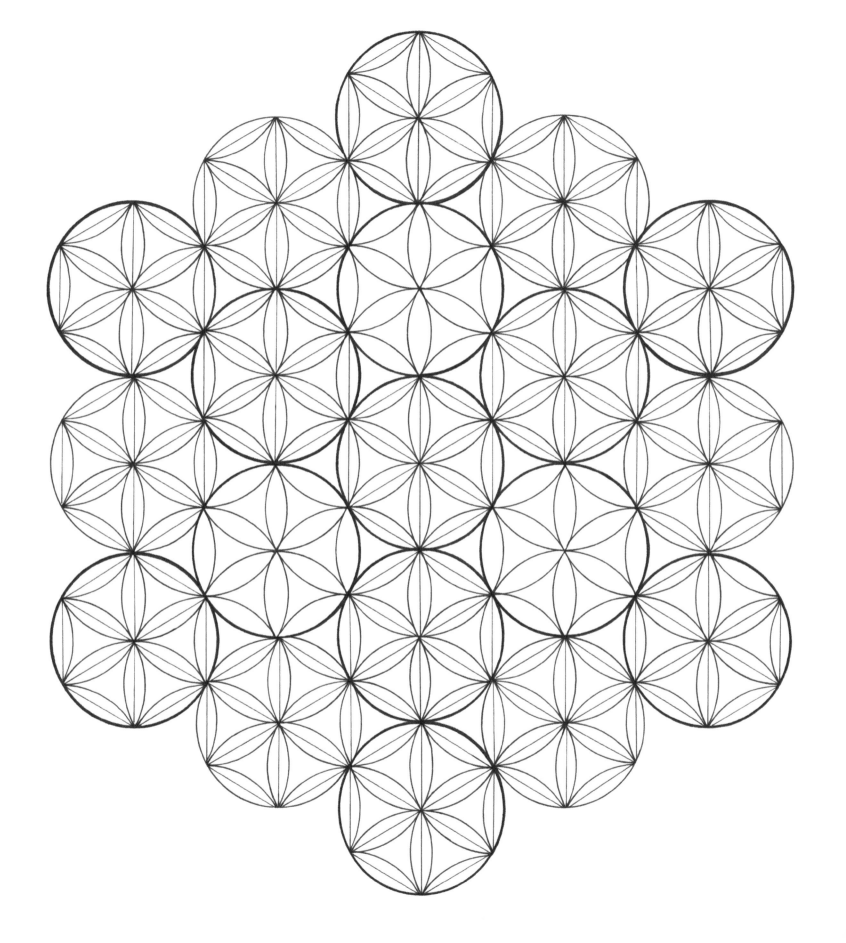

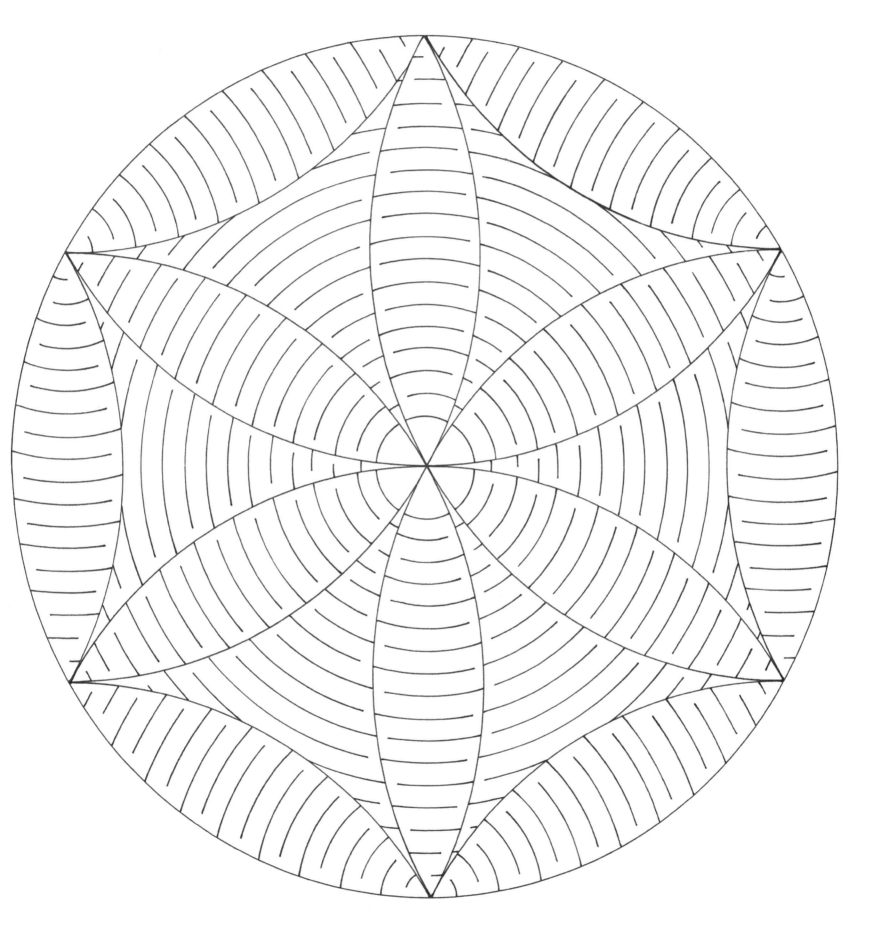

WAVE PATTERNS

Cymatics (from the Greek word for *wave*) is the study of sound and vibration. Ancient mathematicians understood how musical notes were defined by the length of the vibration that caused them, while the pattern of interference between two sets of wave patterns (the inspiration for this image) is studied by schoolchildren to show how simple waves are transmitted through water.

In the last century, quantum mechanics has shown us that light can be simultaneously a particle and a wave, while the discovery of gravitational waves in spacetime has offered further proof of the accuracy of Einstein's theories. Those early thinkers who believed in the music of the spheres, a kind of universal mathematical harmony, would perhaps see a distant echo of their own beliefs in modern science's depiction of the cosmos and the mathematical patterns in which it is rooted.

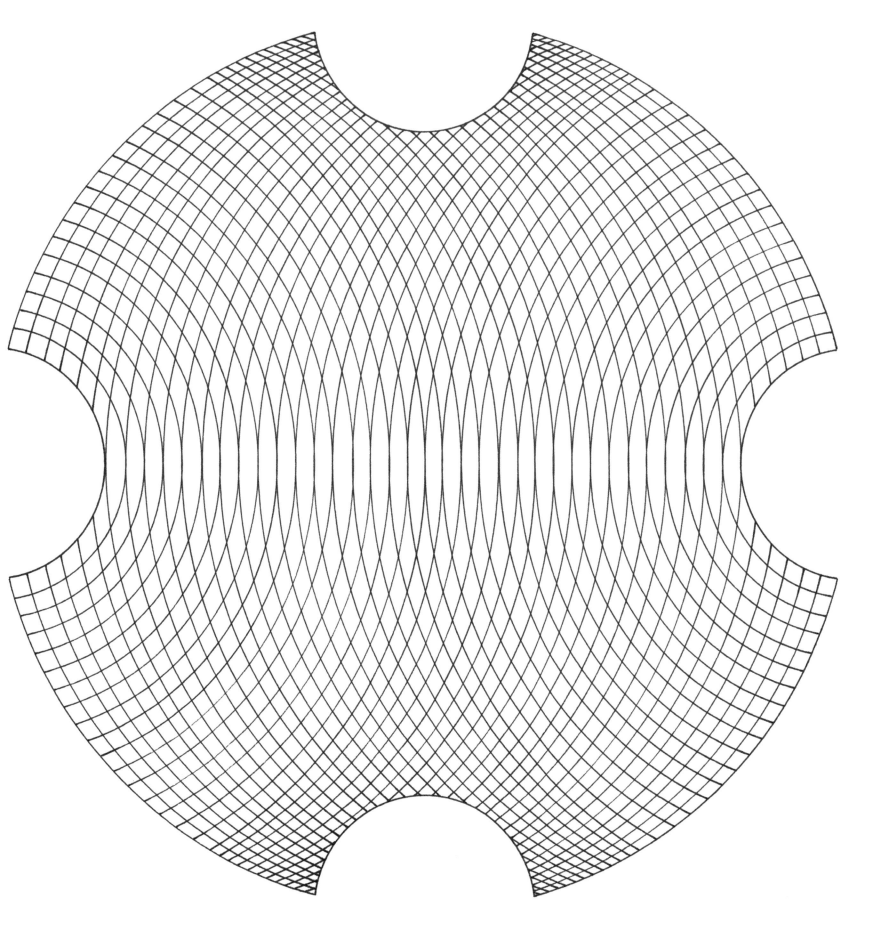

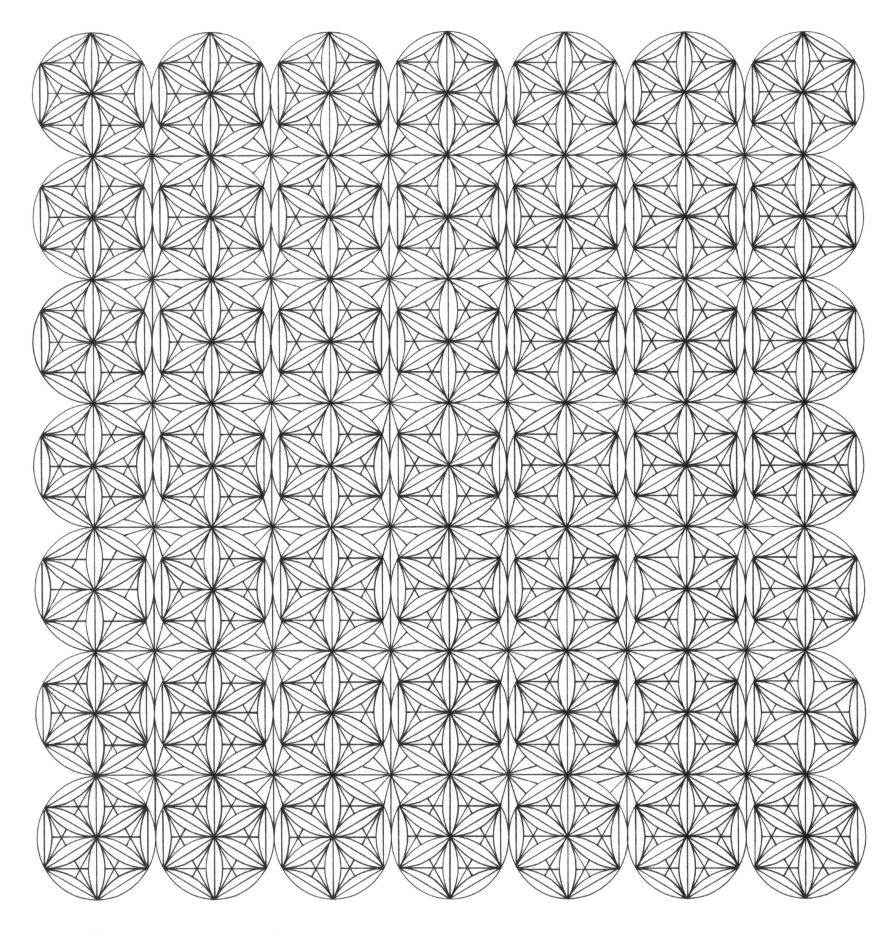

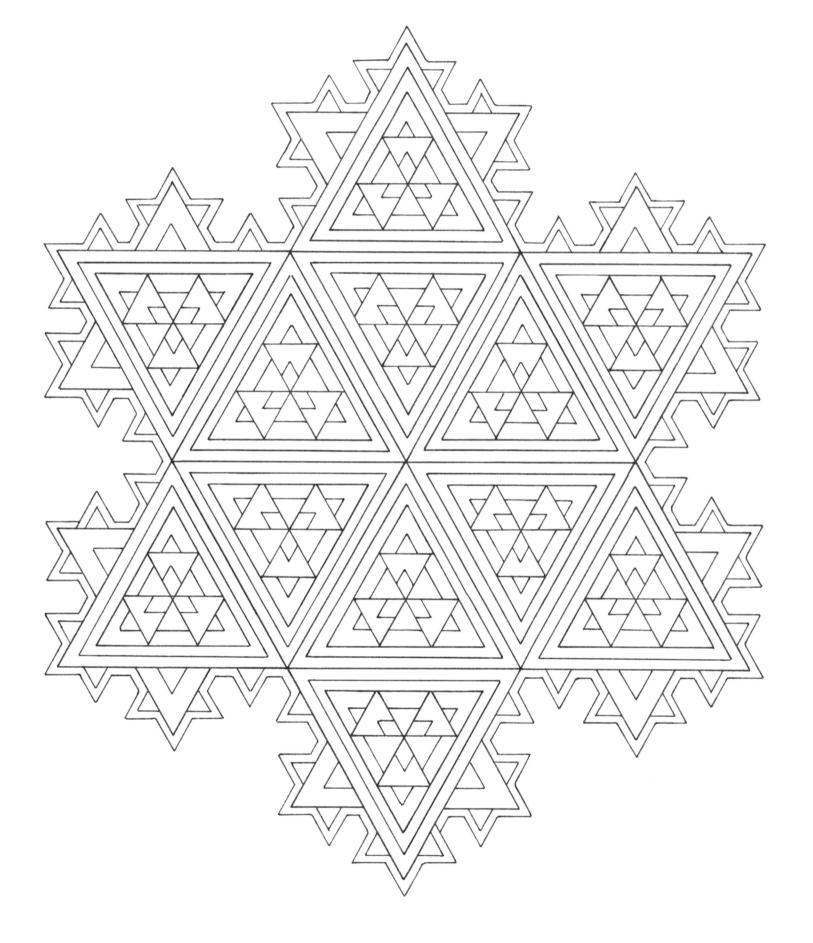

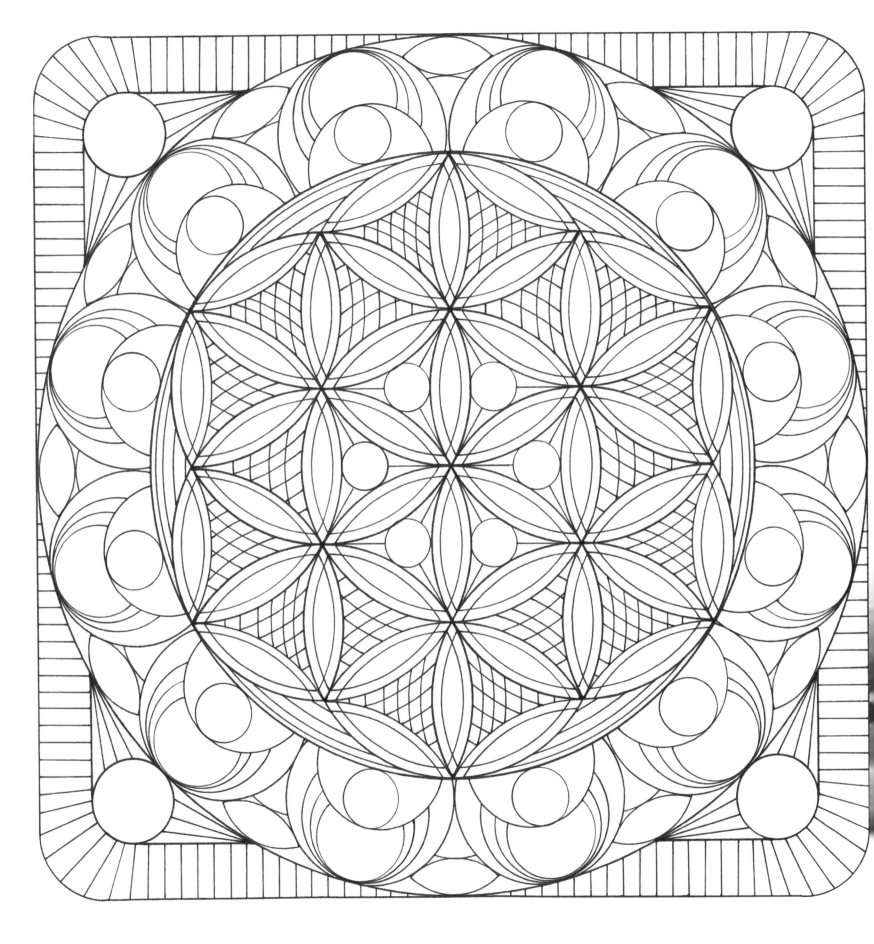

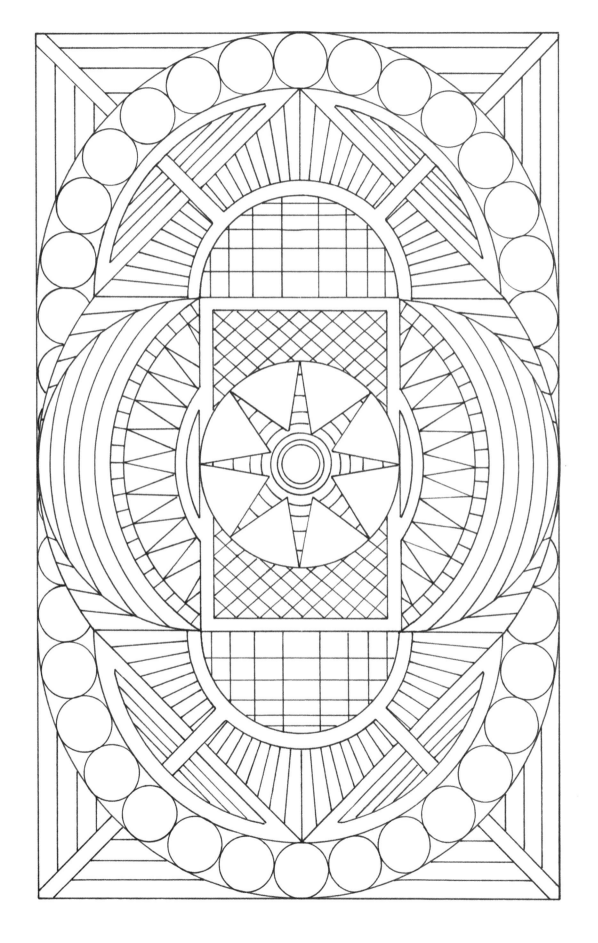

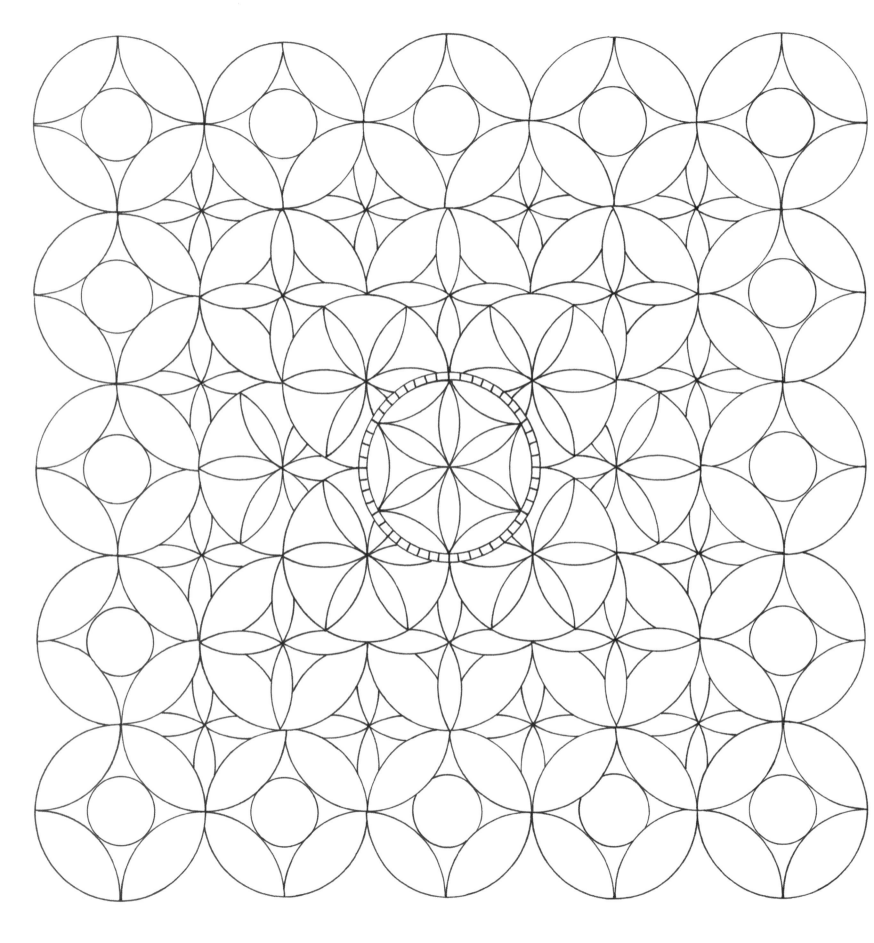

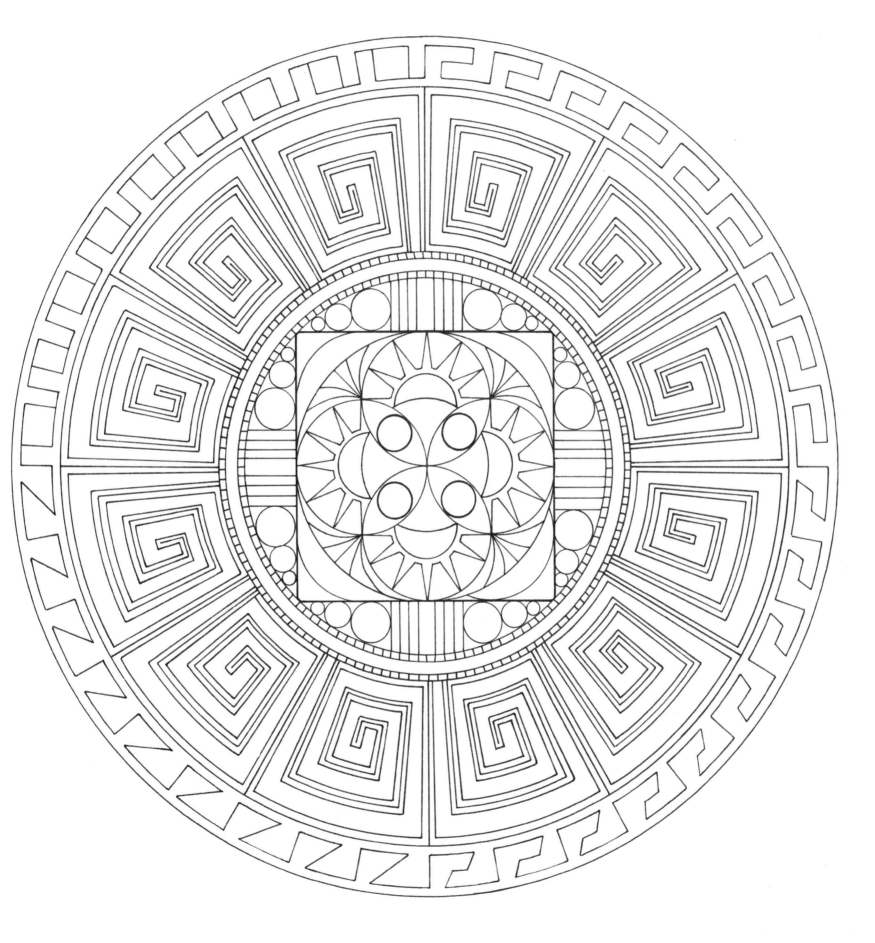

TILING

Tessellation (or tiling), where repeating shapes (known as tiles) are arranged to fill a flat surface without leaving any gaps, is a subject that fascinates many mathematicians. Only three shapes can be used on their own to fill a flat surface—squares, equilateral triangles, and hexagons. However, regular tessellations can be created from many other combinations of shapes.

Opposite, a mixture of squares and parallelograms has been used to make a pattern that resembles three-dimensional cubes, while the image on the page overleaf is based on a combination of hexagons and diamonds. Beautiful Arabic tiling patterns can be seen in buildings such as the Alhambra in Granada, Spain, while the artist M. C. Escher created some extraordinary tessellations out of natural forms such as animals.

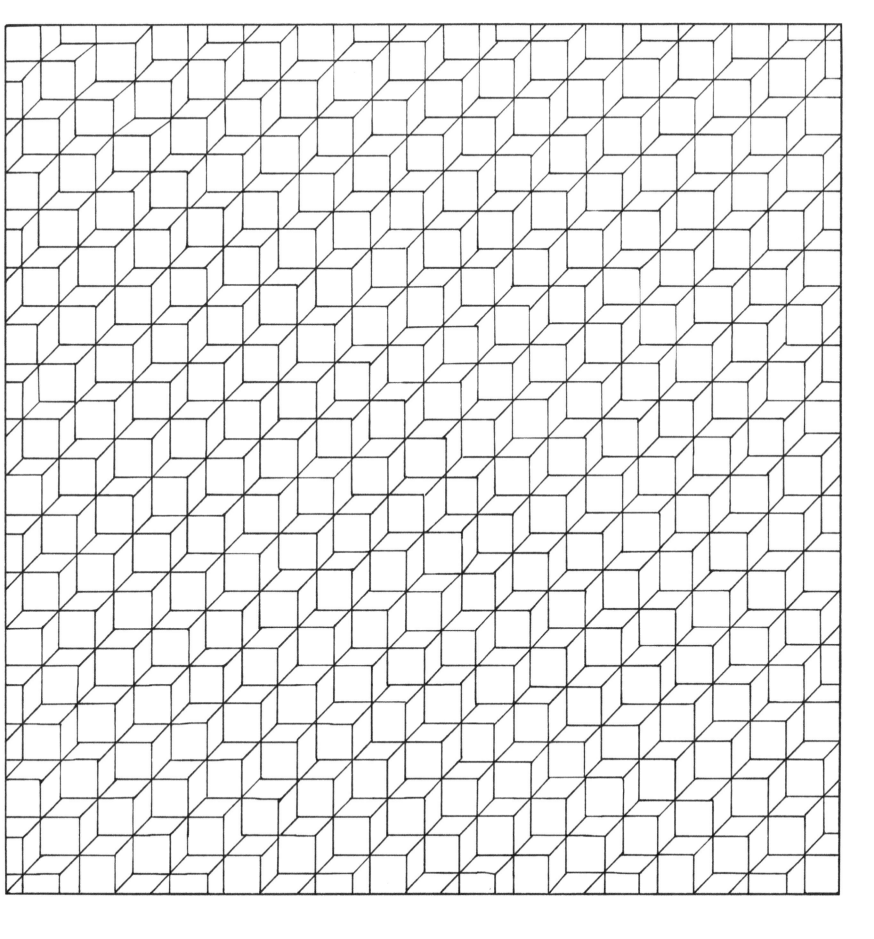

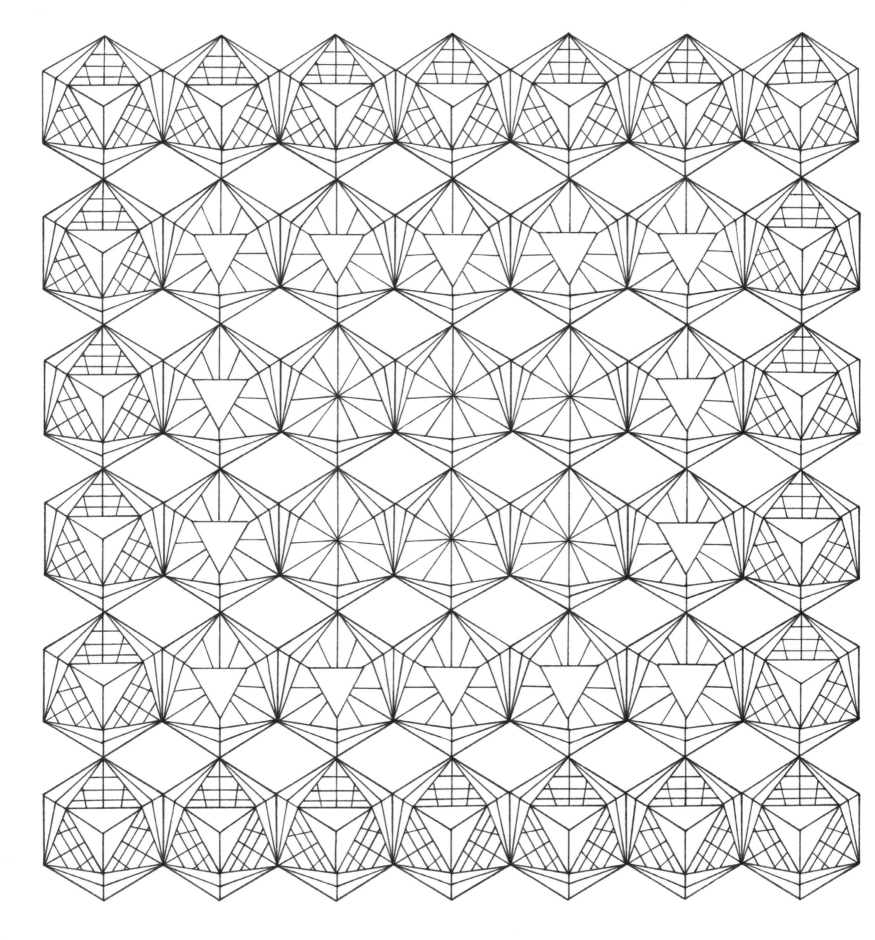

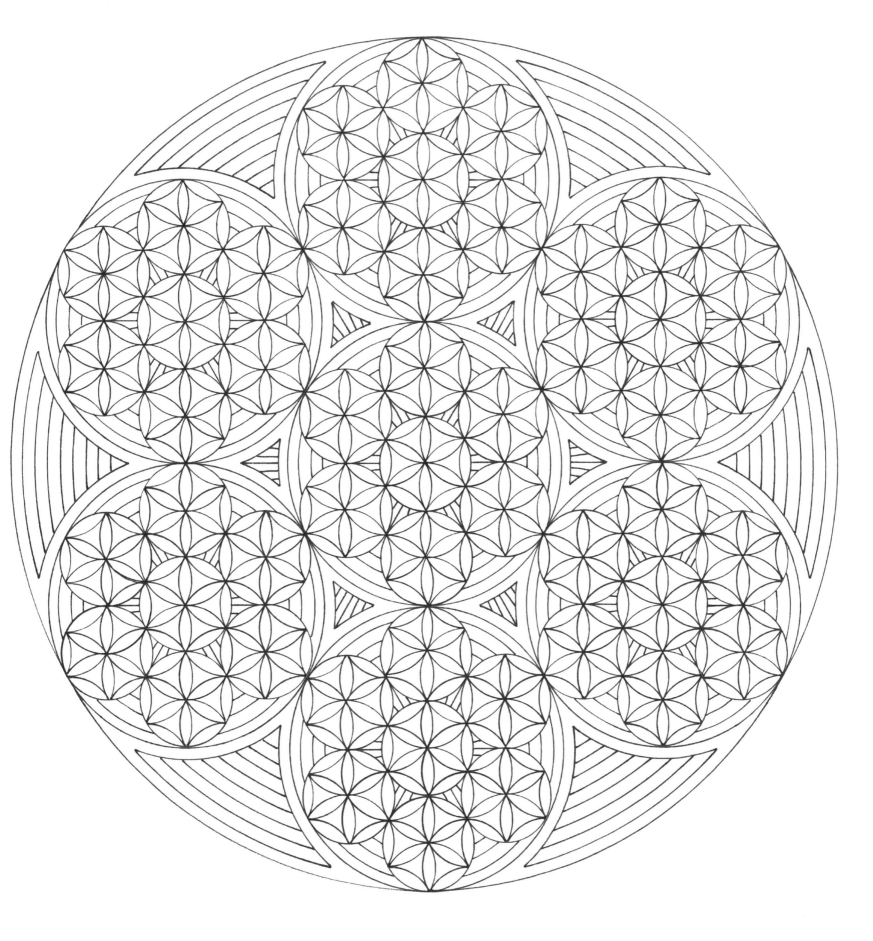

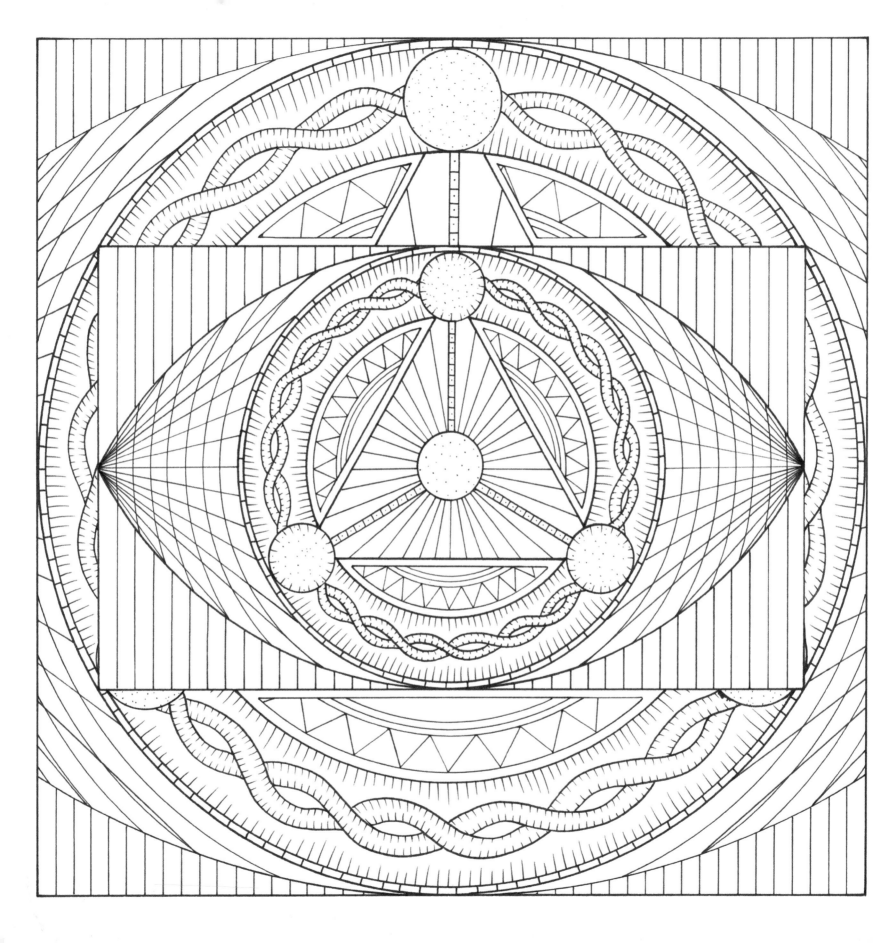